W9-BRD-169

The Jodie Davis Needle Arts School

◆ THE FOUNDATION PIECING LIBRARY ◆

Garden-Inspired Quilt Block Designs

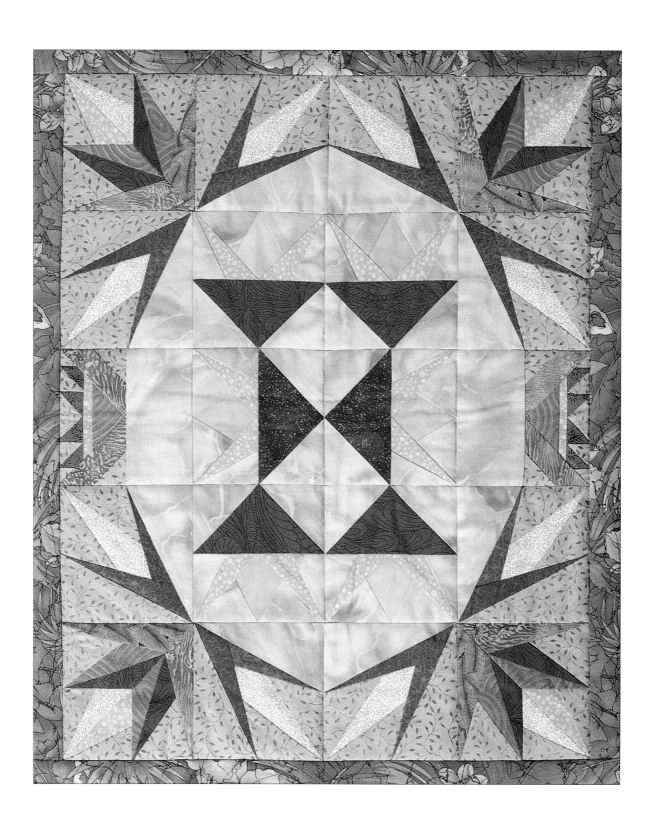

The Jodie Davis
Needle Arts School

◆ **THE FOUNDATION PIECING LIBRARY** ◆

Garden-Inspired Quilt Block Designs

JODIE DAVIS AND LINDA HAMPTON SCHIFFER

FRIEDMAN/FAIRFAX
PUBLISHERS

A FRIEDMAN/FAIRFAX BOOK

© 1996 by Michael Friedman Publishing Group, Inc.

All rights reserved. No part of this publication may be reproduced, stored in a retrieval system, or transmitted, in any form or by any means, electronic, mechanical, photocopying, recording, or otherwise, without prior written permission from the publisher.

Library of Congress Cataloging-in-Publication data available upon request.

ISBN 1-56799-366-4

Editor: Francine Hornberger
Art Director: Lynne Yeamans
Designer: Tanya Ross-Hughes
Photography Director: Christopher C. Bain

Photography by Christopher C. Bain
Illustrations by Barbara Hennig

Color separation by HBM Print Ltd.
Printed in China by Leefung-Asco Printers Ltd.

For bulk purchases and special sales, please contact:
Friedman/Fairfax Publishers
Attention: Sales Department
15 West 26th Street
New York, New York 10010
212/685-6610 FAX 212/685-1307

Visit the Friedman/Fairfax Website:
http://www.webcom.com/friedman

To my grandmother, Edna Mae Pennington Hampton, for teaching me
my first baby stitches and leaving me a legacy of love.

—Linda Schiffer

ACKNOWLEDGMENTS

Thanks to G Street Fabrics in Rockville, Maryland, and Bernie, manager
of the calico department, for maintaining an excellent selection of quilting fabrics.
Applause to Jeannie Welch for sewing all of the blocks and quilts.

CONTENTS

INTRODUCTION ♦ 8

FOUNDATION PIECING PRIMER ♦ 10

BLOCK PATTERNS ♦ 20

BORDERS ♦ 24

ABSTRACT/GEOMETRIC DESIGNS ♦ 28

FLOWERS AND LEAVES ♦ 40

FRUITS AND VEGETABLES ♦ 59

ANIMALS ♦ 68

OBJECTS ♦ **78**

LANDSCAPES ♦ **90**

QUILT DESIGNS ♦ 102

FINISHING ♦ 118

YOU ARE INVITED... ♦ 126

SOURCES ♦ 126

BIBLIOGRAPHY ♦ 127

INDEX ♦ 127

INTRODUCTION

WHAT IS FOUNDATION PIECING?

Foundation piecing is simply the fastest and by far the easiest method ever devised for constructing quilt blocks—so easy in fact, that even a new quilter can make beautiful blocks. The technique is foolproof!

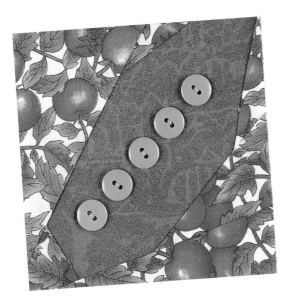

along a marked line. The two fabric pieces are pressed open into place. Additional pieces are added until the block is complete. Finally, the blocks are sewn together and voilà—a completed quilt top!

THE PATTERNS

The patterns included in this, the second in The Foundation Piecing Library series, are based on a Garden theme. Flowers, fauna, and other natural elements combine to form a potpourri of block designs.

THE PROCESS IN A NUTSHELL

Foundation pieced blocks are constructed by sewing along lines marked on a paper or fabric foundation. The foundation provides stability and the lines accuracy.

First, the block design is transferred to the foundation. With the marked lines face up, two pieces of fabric, right sides together, are placed under the foundation and stitched to the foundation

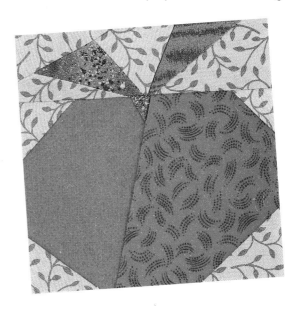

Each block design is rated for ease of construction, designated by the number of diamonds appearing on the pattern page. If you are just beginning, select a pattern from those featuring one diamond. The more challenging patterns found in this book have three diamonds.

Foundation pieced blocks are the perfect opportunity for you to use those precious scraps you've been saving. And remember not to limit yourself to the block sizes that are offered in the book. Foundation piecing can make quick and perfect work of any size block.

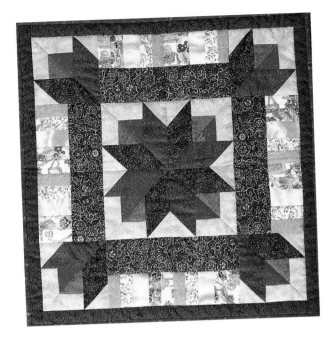

THE QUILTS

Twelve quilt designs, each using one or more of the patterns from the Quilt Block Patterns section, are offered in the Quilt Design section. These quilts provide the perfect opportunity to put your new skills to use in creating a finished project.

What could be easier? No templates, no marking, no painstaking cutting. Foundation piecing is easy enough for a beginner, yet challenges the seasoned quilter. Above all, foundation piecing offers accuracy and speed. And it's fun!

JODIE DAVIS

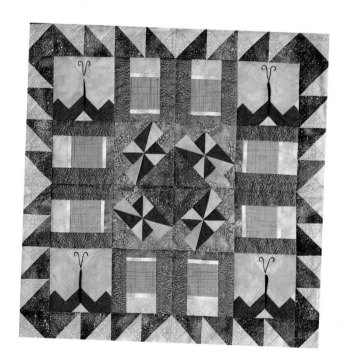

FOUNDATION PIECING PRIMER

This chapter provides all the information you need to construct the quilt blocks shown in this book. The only requirement is that you can sew a straight line. That's it!

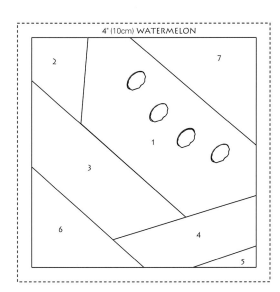

CALLING ALL HAND PIECERS

These blocks make excellent carry-along projects for trips, in waiting rooms, and during after-school practices. Only a few sewing supplies and small scraps of fabric are needed. A fabric foundation is strongly recommended as paper is more difficult to sew through by hand.

THE DESIGNS

The block and border designs in this book are full-size, ready to be traced and used. Each is shown in 2" (5cm) and 4" (10cm) sizes. The numbers on the blocks indicate the sewing sequence for the fabric pieces.

The solid lines on the block designs represent the sewing lines. A dashed ¼" (6mm) seam allowance has been added all around the outside of each block.

NOTE: If you use a photocopier to enlarge a block to another size, you'll need to redraw the seam allowance so it's ¼" (6mm).

NOTE: You will be sewing from the wrong (back) side of the blocks. The marked side of the foundation is the back. For this reason the finished block will be a mirror image of the illustrated designs in the book. Notice that the photos of the blocks are mirror images of the illustrated blocks. Of course, for symmetrical blocks there will be no difference between the illustrated and sewn blocks.

Asymmetrical block

Symmetrical block

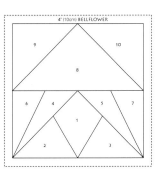

CREATIVE OPTIONS: For exciting and unusual quilts, play with block orientation and combinations. Look at the patterns, their mirror (flipped) images, and combinations of both. To do this easily, use a photocopy machine to make several copies of the block pattern, then rearrange these copies until you like the result. You may wish to color the blocks with colored pencils or crayons to get a better feel for how they will work together.

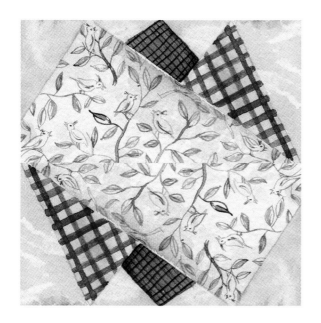

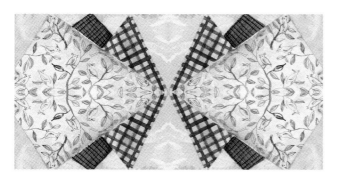

FOUNDATION OPTIONS

PERMANENT FOUNDATIONS

A fabric foundation is permanent. The patchwork pieces are stitched to the base fabric, which is usually muslin. The foundation then becomes an additional layer in the quilt sandwich. A benefit for some projects, for instance to add body to a wall hanging or vest, a fabric foundation isn't always the best choice for others, such as a project calling for extensive hand quilting, or a miniature quilt that shouldn't be too stiff.

Choose high-quality muslin for your foundation, and be sure to prewash, especially if the finished project will be laundered.

Use the Olfa 6" [15cm] square template to cut perfectly square fabric foundations of any size.
ELEANOR LEVIE, DARIEN, CT

TEMPORARY FOUNDATIONS

Paper of many types is excellent as an inexpensive foundation. It provides more stability for piecing than muslin and eliminates the additional layer of a permanent fabric foundation, allowing for easier hand quilting. The paper is removed by tearing after the block is completed. In some cases, this can cause fraying of seam allowances and distortion of the block, or some bits of paper may remain stuck in the stitches. Avoid these problems by sewing with a shorter stitch length. This way, removing the paper will be similar to tearing postage stamps apart.

Almost any paper is appropriate for foundation piecing. Copy, computer, and typing paper are readily obtainable. Supermarket freezer paper is favored by many quilters. The dull side is marked with the block pattern and the shiny side is pressed to the fabric with a dry iron and a press cloth. As another option, tracing paper has the advantage of lighter weight, so stitches won't distort as readily when the paper is torn away.

TIP: Leave the paper foundation in place until after you seam the blocks together. The blocks will be easier to align, and won't become distorted by tearing the paper away. This also eliminates concern about the grainline of the block edges.

When making paper foundation patterns, whether on computer or by hand, I like to print on newsprint. This has two advantages: it tears easily, and it is porous enough that the ink shows through a tiny bit to the back of the paper. This makes placement of fabric pieces much easier.

AUDI GERSTEIN
LIVINGSTON, NJ

Here's a tip to make your paper removal easier. After you stitch a seam, score the paper at the seam while trimming. Then when you're ready to remove the paper, dampen the paper slightly with a sponge or spray it once with a fine spray. This will make your paper removal much easier! Don't get it too wet. If you do, then just press it a bit with a warm iron.
Or use a cheap-grade typing paper or onionskin paper, and press the finished block to scorch the paper. The paper becomes brittle and you can practically "snap" it off!

ANNIE TOTH,
MOORPARK, CA

Newsprint is a favorite paper foundation for many quilters. Susan Druding of Berkeley, CA purchases newsprint at a local paper warehouse. It tears easily, is cheap, and, as Audi Gerstein of Livingston, NJ points out, it is porous enough that the ink shows through a tiny bit to the back of the paper. This makes placement of fabric pieces much easier.

TRANSFERRING THE BLOCK DESIGNS

To reproduce the block designs on paper, trace or photocopy the pattern from the book. When using tracing paper, draw the lines with a ruler to ensure accuracy. Be sure to include the piecing sequence numbers as well.

A copy machine makes quick work of reproducing patterns. To test the precision of the copies, make one copy of a block and measure it on all sides to be sure the size is correct. Cut along the outside, dashed lines.

To transfer the block designs to fabric, you may place the muslin over the block design on a light table or tape to a sunny window and trace. As an alternative, use heat transfer pens and pencils for speedy marking of fabric foundations. Following the manufacturer's instructions, make a transfer on paper and check for accuracy. You can then make multiple replicas on fabric or paper using the same transfer.

NOTE: Be sure to use marking tools such as pencil or permanent fabric pens when marking the fabric foundations. Pigma and Pilot SC-UF are good examples of the latter (see Sources). If the ink used is not stable, it can bleed into the block front during construction or after the quilt is complete.

BLOCKS IN ANY SIZE

If you require block sizes other than the two offered, start with the 4" (10cm) block and refer to the following chart to adjust the size; remember to adjust the seam allowances to ¼" (6mm) all around:

For a block size of:	Set the copy machine to:
3" (7.5cm)	75%
5" (12.5cm)	125%
6" (15cm)	150%
8" (20cm)	200%

FABRICS

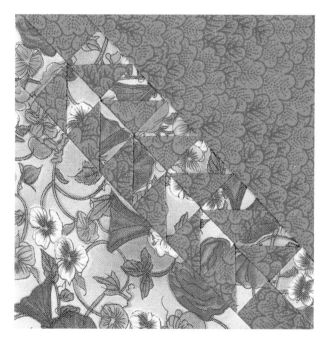

Fabric companies offer a delicious variety of fabrics for the quilter. High-quality all-cotton fabrics are a joy to work with. Their close weave results in wonderfully crisp creases and patchwork pieces that retain their shape.

Many quilters are exploring the possibilities of such non-traditional fabrics as lamé, flannel, and other

blends that may catch their fancy. For flimsy fabrics such as tissue lamé, fuse interfacing to the back of the fabric before use. (Tricot-backed lamés are preferred as they don't fray, nor do they require backing with interfacing.) A muslin foundation will give thin, delicate fabrics the extra support they require.

PREPARING FABRICS

If you are using small scraps of fabric to make blocks, be sure the piece you use is at least ¾" (2cm) wider than the final patch dimensions. If in doubt, put the fabric on the back of the printed pattern and hold it up to the light.

For larger scraps or new yardage, cut strips at least ¾" (2cm) wider than the desired final patch. Or, cut strips 6" (15cm) wide (for 4" [10cm] blocks) or 3" (7.5cm) wide (for 2" [5cm] blocks); these can be cut later across the length into strips to fit specific patch spaces as you piece the blocks.

> A light box is very helpful when foundation piecing. If I just can't eye up the fabrics holding them up to the light, I turn on the light box and can see the line/fabric every time. It is especially helpful for the darker fabrics which tend to just fade into the line on the other side.
> PATRICIA WILSON, SUNNYDALE, CA

SEWING

For paper piecing, set your sewing machine to 18 to 20 stitches per inch (2.5cm) or a stitch setting of 1½, depending upon the make of your machine. The short stitch length creates closely spaced perforations in the paper, which will facilitate tearing it away later. At the same time, it stabilizes the seam.

For final machine assembly of the quilt top use your normal stitch length.

Use an 80/12 needle. Depending upon the foundation you use, switch to a 90/14 needle if you have trouble tearing the paper away.

Choose your thread color according to the fabrics selected. Light gray is a good choice for assorted lighter fabrics; dark gray when working with darker fabrics.

> To prevent mix-ups when making multiples of a block, make a guide by making an extra copy of the block and gluing appropriate fabric scraps in place. Hang the copy where you can see it easily as you sew the blocks.

FOUNDATION PIECING METHOD

To demonstrate the foundation piecing method, I have chosen an easy block as a beginning project. To understand the techniques, follow these steps, making your own practice block in the process.

REMEMBER: The marked side of the paper will be at the wrong side of the finished block. Thus, the finished block will be a mirror image of the illustrated pattern.

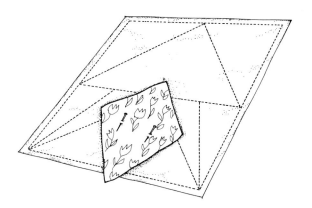

I key my paper foundations for easier and faster piecing. By coloring in the sections (1, 2, 3...) according to the fabrics that go there, I eliminate confusion and speed up my piecing.

ELLEN ROBINSON, GERMANTOWN, MD

1. Beginning with the shape marked #1 on the pattern, place the fabric you've chosen for piece #1 with the wrong side against the unmarked side of the foundation paper or fabric. Hold the foundation

and fabric up to a light source to help you see the marked lines. Pin in place. Make sure the fabric covers the shape with at least ¼" (6mm) all around to spare. Be generous with the fabric: it's better to have too big a piece now than to end up short later.

2. Cut a piece of fabric for piece #2. Since the back of the block design is facing you, hold the fabric wrong side up to cut it. Pin piece #2 against piece #1, with right sides together. Working from the marked side of the foundation, stitch along the line; begin and end the stitching a few stitches beyond the ends of the line.

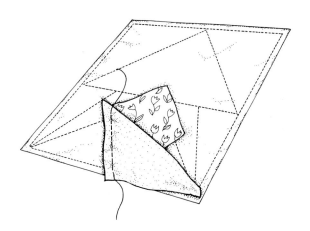

If you have trouble seeing the marked line when sewing, switch to a transparent or open toe foot on your sewing machine.

3. Trim the seam allowance to ¼" (6mm). For blocks 2" (5cm) square or smaller, trim to ⅛" (3mm).

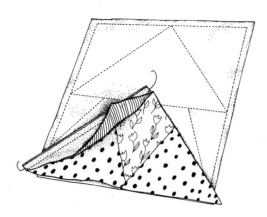

NOTE: Be careful not to cut into the foundation when trimming seam allowances. Feel for the foundation with your fingers or scissors—or look. It will save you a lot of grief!

Fold piece #2 into place and finger press. Then press with a dry iron—no steam.

4. In this manner, add piece #3 and all subsequent pieces. Press as you go.

5. Using a ruler or square template and rotary cutter, trim the edges of the block, leaving ¼" (6mm) seam allowance on all sides of the block as indicated on the pattern by short dashed lines.

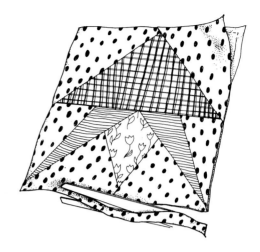

OPTIONAL: When using a permanent foundation some quilters baste around the finished block from the right side, just inside the seam allowances. This anchors the fabric pieces so they won't shift and get caught in the seams when you're joining the blocks.

When making multiple blocks using one pattern, I construct the blocks assembly-line fashion. I sew piece #1 for each block first, then go back and do #2 for every block, etc.

KAREN KRAFT, CALEDONIA, MI

If you wish to center a special fabric motif or fill a shape evenly, be sure to check the alignment by holding the fabric and foundation up to the light.

SUBUNIT BLOCKS

A few block designs consist of two (or more) pieces, such as two triangles or rectangles (subunits). The two subunits are prepared using foundation piecing techniques, and then joined together to make a complete 2" (5cm) or 4" (10cm) block, matching points and seams where necessary.

WHAT ABOUT GRAIN?

For all patchwork it is important to be aware of fabric grain considerations. On most fabrics you can easily see the intersecting threads, or grainlines of the fabric weave. The lengthwise grain (parallel to the selvedges) has less "give" or elasticity than the crosswise (perpendicular to the selvedges) grain.

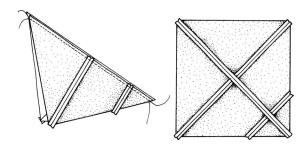

If you pull a piece of fabric diagonally (at a 45-degree angle) to the grain, you will get a lot of stretching. This is the bias of the fabric. When you assemble patchwork blocks of any kind you need to be aware that having bias edges on the outside edges of the block will cause the block to stretch. The resulting variance of edge lengths will hinder easy joining of the blocks and prevent your quilt from hanging or laying straight.

One of the virtues of foundation piecing is that this concern with grainline can be minimized. If using a permanent fabric foundation, be sure your pattern is transferred to the foundation fabric even with the grain lines. Then you will not need to be concerned with the grainline of any of the patchwork fabrics you use to make your block, allowing you to orient the printed pattern on your patch fabric to please your eye.

However, if you use a paper foundation and wish to remove the paper before final quilt assembly, you need to be careful not to have bias edges along the outer edges of your blocks. You can also leave the paper foundations in place until after seaming the blocks to alleviate this worry over outer bias edges. Be aware that paper removal can be tedious when working with a completed top. You may find a good pair of tweezers helpful in the paper removal process.

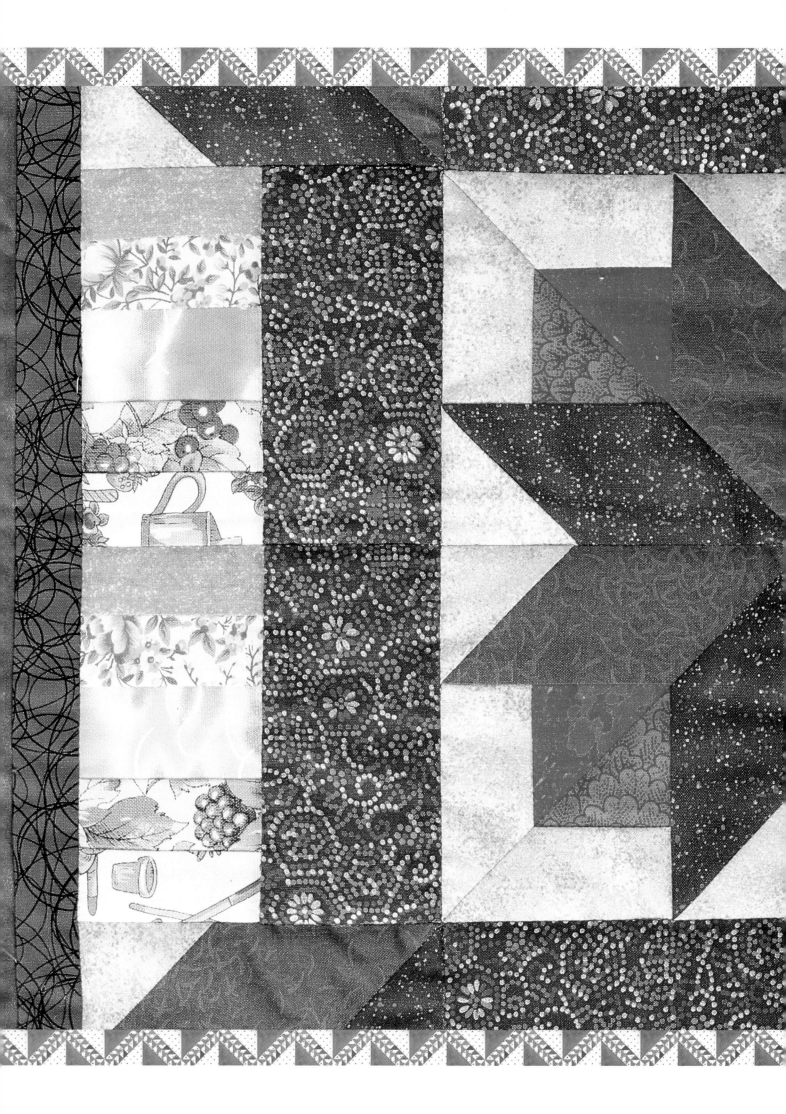

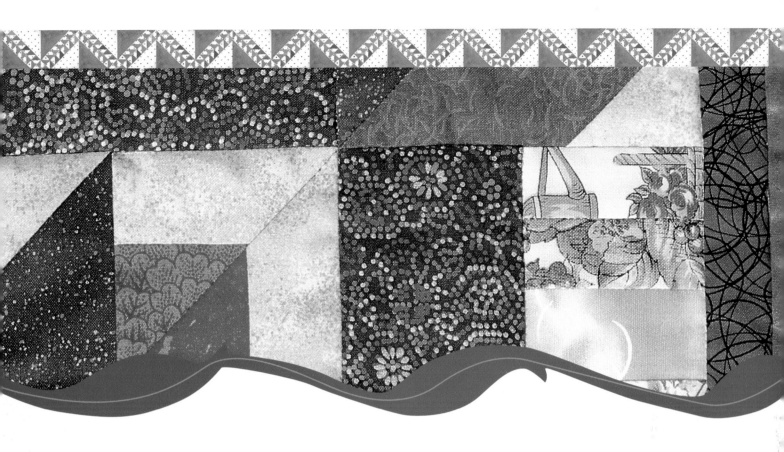

◆ CHAPTER TWO ◆

BLOCK PATTERNS

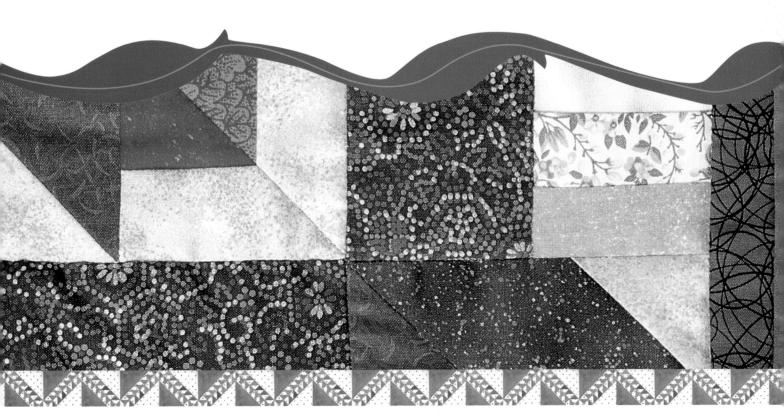

BLOCK PATTERNS

Nature has been an enduring source of inspiration for countless generations. The raw power of great cataclysmic events made lasting impressions on the cultures and histories of ancient peoples, spawning myths that endure to modern times. Today, more commonplace natural events—thunderstorms, tornadoes, earthquakes—still make us pause, putting our personal problems into the wider natural perspective.

The natural world today, no less than in our ancient past, also offers relaxation, emotional release, and rejuvenation to all. A walk outdoors on a fine spring morning can ease many a sorrow, and soothe a stress-filled life, offering peace and beauty as balm for personal cares.

There is a place for everyone, even in this modern world, to find joy in the outdoors—from the splendors of the wildest lands and the beautiful landscapes of distant places to the hours we spend digging and pruning in our own gardens and flower beds. Bird watching, kayak rides, nature walks, bicycle tours, safaris, and country picnics all serve to enrich our lives and maintain the connections to our planet Earth that we so desperately need for psychic balance.

In the depths of a gray, cold winter we dream of crocus, daffodil, tulip, and snowdrop—bright color

to lighten our hearts and warm our days. We long for sweet green grass, tickling our bare feet and the smell of sunshine. Some of us are lucky enough to be able to escape winter by traveling great distances to find spring in warmer climates. But those of us who must abide winter can now bring some of our warm-weather dreams to reality, creating an artificial springtime to overcome the grim cold.

Quilting with natural themes gives us this retreat. With our creations, we can decorate our homes with the bright hues of spring, summer, or fall as an antidote to winter's bland palette, or as lasting memories of natural beauty. We can make gifts for those we love or for those we wish to thank for some kindness or service. What better gift is there to give than a gentle, colorful reminder of nature's glory—whether flower, vegetable, animal, or landscape.

Research on the psychological impact of color is bringing to light what many of us intuitively understand—that color is vitally important to our well being. What we see in our surroundings influences our mood, our peace of mind, our energy level, our human resources. This holds true in quilting as well.

As you work on your fabric gardens, enjoy playing with the color content of your piece. Notice what colors please you and make your heart sing.

Savor the process of producing your foundation patchwork as much as the final quilt, whether you keep it or give it away. Joy in the making enriches the life of the quilter and of the recipient of the quilt. You can experiment with the effects of light, the scale and texture of prints, and the interplay of colors while making your fabric garden or landscape.

Foundation piecing offers an excellent doorway for beginners (even children) to enter the world of quilting. The technique is easy to learn and mastery allows freedom for creative enrichment.

In this, our second book of foundation piecing projects, I hope that you will find the creative energy to apply the beauty of the natural world to your own quilting projects. Use these designs to bring the glory of the great outdoors into your home or give a remembrance to someone you love.

Above all, enjoy the process of creation and be sure to return often to the natural world for inspiration. Whether you make a small block or a full-size quilt, I wish you continuing success with your adventures in quilting.

LINDA HAMPTON SCHIFFER

PATTERN COMMENTS

◆ = 1 diamond (easy)
◆◆ = 2 diamonds (modest difficulty)
◆◆◆ = 3 diamonds (challenging)

BORDERS

FENCE TOP BORDER ◆

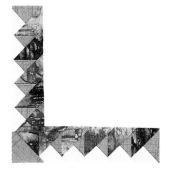

This is a simple but very effective border for a floral quilt. Its sharp geometry can be a good foil for the bright flowers in your fabric garden.

BRICK BORDER ◆

Well bordered beds are a pleasure to behold and to maintain. Choose fabrics to enhance and frame your garden.

TWISTED RIBBON BORDER ◆

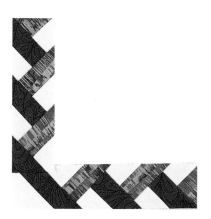

This is a lovely way to finish off that floral bouquet or corner garden. There are many effective ways to assemble the subunits of this border; experiment to find your favorite.

LATTICE FENCE BORDER ◆

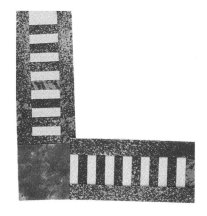

Lattice fencing is a good backdrop for flower gardens. This one is very easy to piece into whatever length you need.

FENCE TOP BORDER

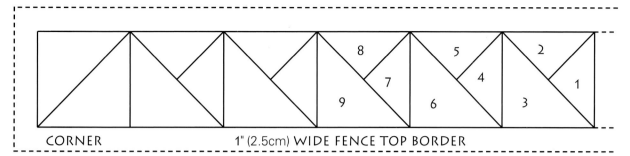

CORNER 1" (2.5cm) WIDE FENCE TOP BORDER

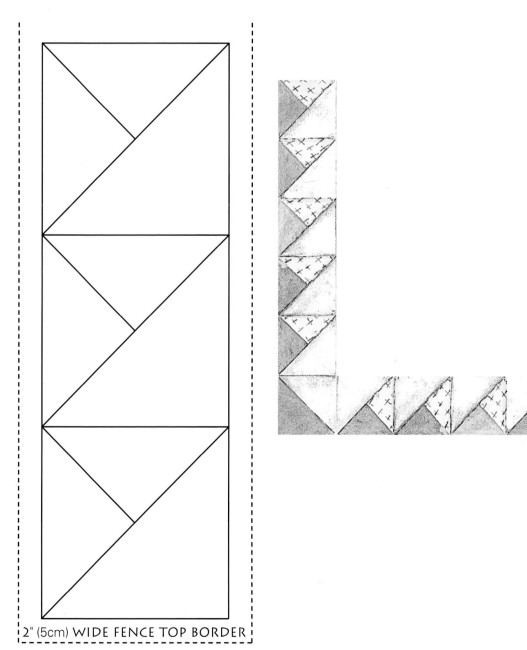

2" (5cm) WIDE FENCE TOP BORDER

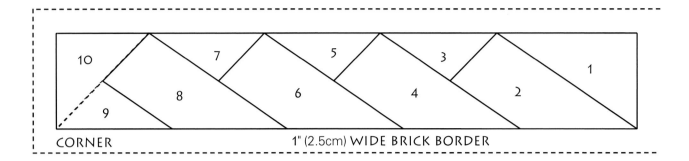

BRICK BORDER

10 7 5 3 1

8 6 4 2

9

CORNER 1" (2.5cm) WIDE BRICK BORDER

TWISTED RIBBON BORDER

10 6 2

9 5 1

11 7 3

8 4

CORNER 1" (2.5cm) WIDE TWISTED RIBBON BORDER

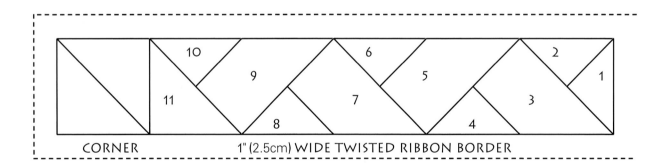

LATTICE FENCE BORDER

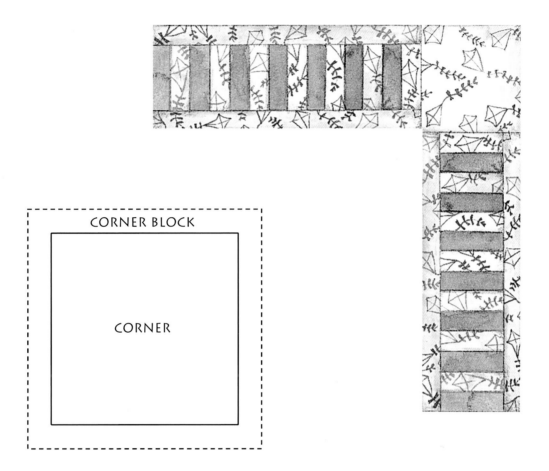

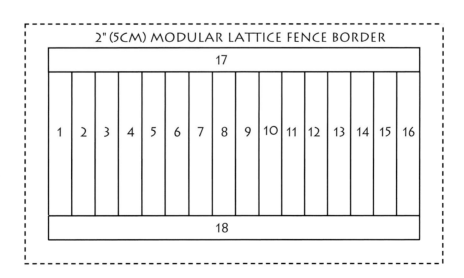

CORNER BLOCK

CORNER

2" (5CM) MODULAR LATTICE FENCE BORDER

17

| 1 | 2 | 3 | 4 | 5 | 6 | 7 | 8 | 9 | 10 | 11 | 12 | 13 | 14 | 15 | 16 |

18

CHARMING GARDEN ◆

Select your favorite floral and leafy prints and trade charm squares with your friends. Sign your blocks with permanent markers or embroidery as a memento of friendship.

BRIGHT STARS ◆◆

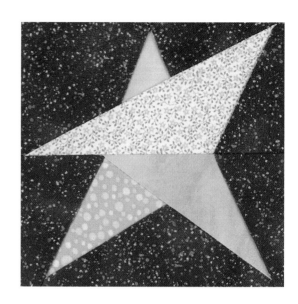

One of my favorite blocks, this pattern can be dramatic or soft, bright or romantic, depending on your fabric and background choices. Worthy of a quilt to itself or as an enhancement to your garden skies.

GARDEN RAMBLE ◆◆

This block takes time, but is worth the effort. Enjoy choosing fabrics to make your ramble a pleasure.

LATTICE FENCE BORDER

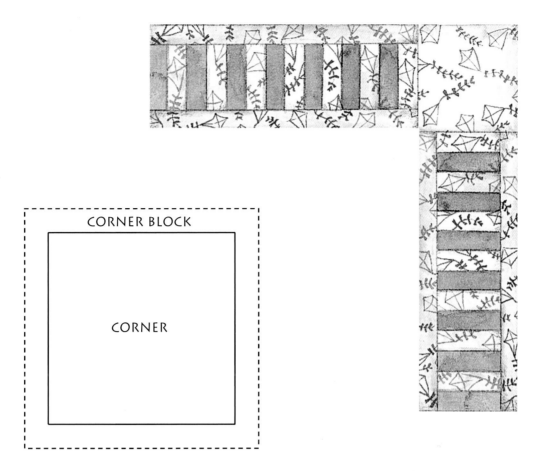

```
CORNER BLOCK

        CORNER
```

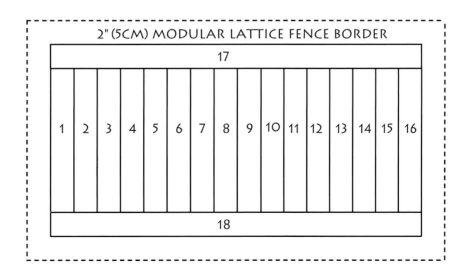

2" (5CM) MODULAR LATTICE FENCE BORDER

17															
1	2	3	4	5	6	7	8	9	10	11	12	13	14	15	16
18															

ABSTRACT/ GEOMETRIC DESIGNS

FLORAL WHIRL ◆◆◆

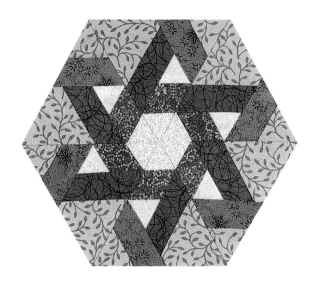

This pattern takes patience to make but the rewards are clear. Play with color to create your own version of the hidden flowers.

FLOWER STARS ◆◆◆

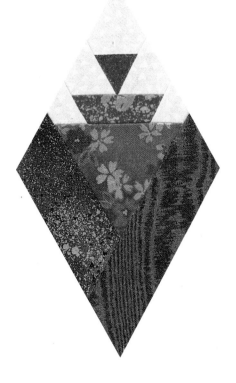

These subunits make pretty diamond-shaped flowers. Assemble them into the stars shown or play with other diamond layouts.

GARDEN PATH ◆

This traditional pattern can be very effective as an outer border or in sets to make internal medallion borders. You can choose subdued fabrics for a brick walkway effect or exotic prints for an exciting frame.

GARDEN PARTY ◆

This easy geometric pattern reminds me of twin-kling lights and swirling music. You can fit them into your garden individually in niches, use them for a border, or play with geometric layouts.

WHIRLING STAR ◆◆

These subunits are very easy to make and to assemble into striking stars with sharp rotation. Play with pattern and fabric to create dancing energy in your quilts.

THORNY TRAIL ◆

This block has great energy with its spikes and diagonal movement. You can make it in striking, high-contrast solids or an assortment of scrappy prints.

CHARMING GARDEN ◆

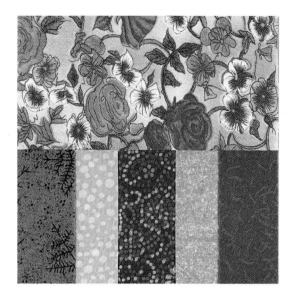

Select your favorite floral and leafy prints and trade charm squares with your friends. Sign your blocks with permanent markers or embroidery as a memento of friendship.

BRIGHT STARS ◆◆

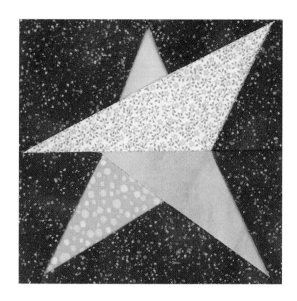

One of my favorite blocks, this pattern can be dramatic or soft, bright or romantic, depending on your fabric and background choices. Worthy of a quilt to itself or as an enhancement to your garden skies.

GARDEN RAMBLE ◆◆

This block takes time, but is worth the effort. Enjoy choosing fabrics to make your ramble a pleasure.

FLOWER STARS

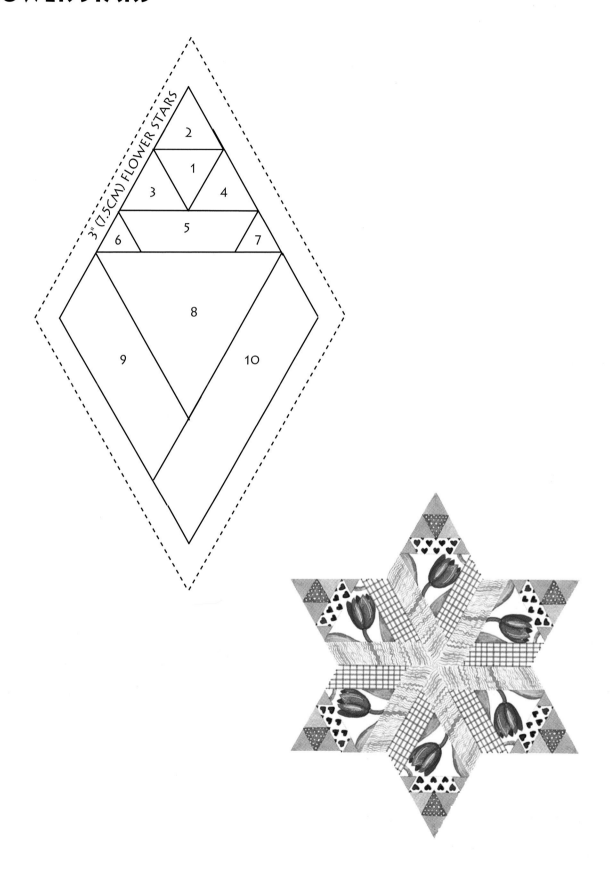

3" (7.5CM) FLOWER STARS

FLORAL WHIRL

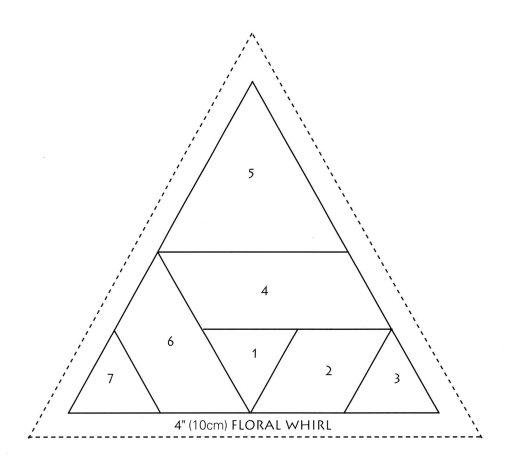

4" (10cm) FLORAL WHIRL

GARDEN PATH

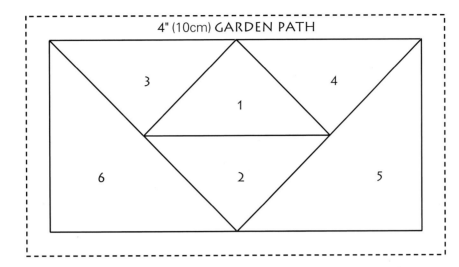

4" (10cm) GARDEN PATH

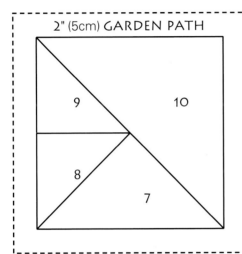

2" (5cm) GARDEN PATH

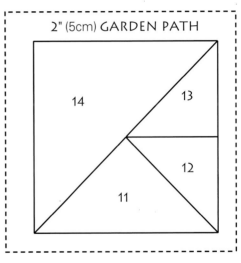

2" (5cm) GARDEN PATH

GARDEN PARTY

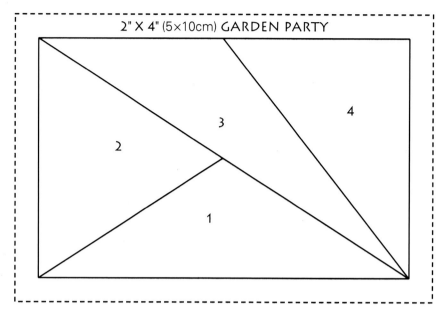

2" X 4" (5×10cm) GARDEN PARTY

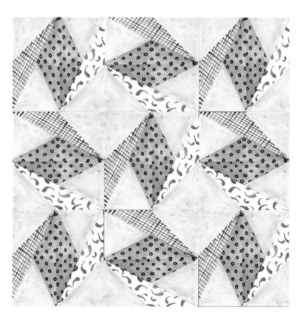

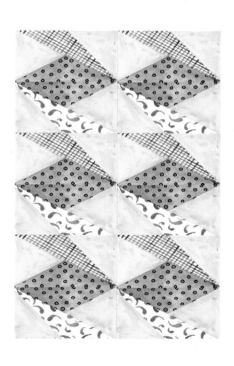

THORNY TRAIL

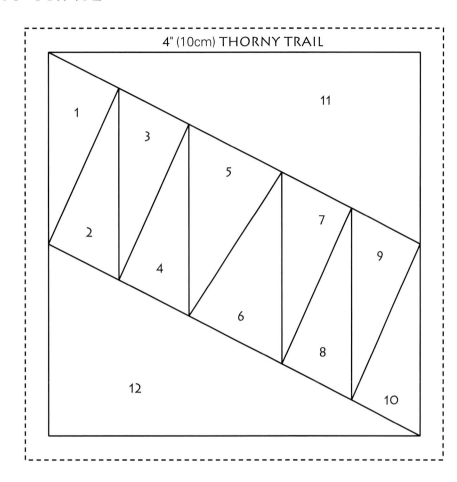

4" (10cm) THORNY TRAIL

1
2
3
4
5
6
7
8
9
10
11
12

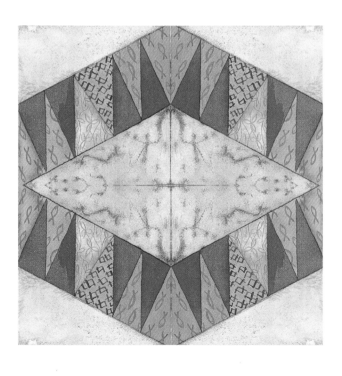

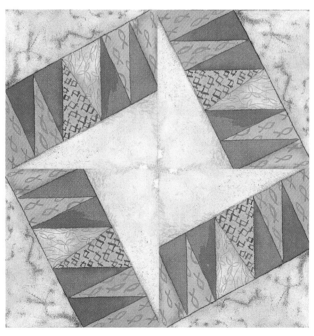

WHIRLING STARS

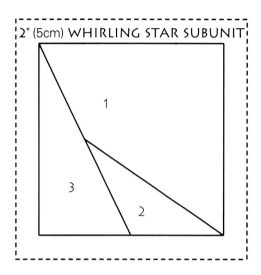

2" (5cm) WHIRLING STAR SUBUNIT

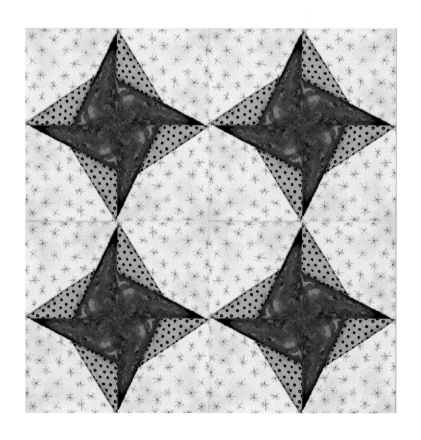

CHARMING GARDEN

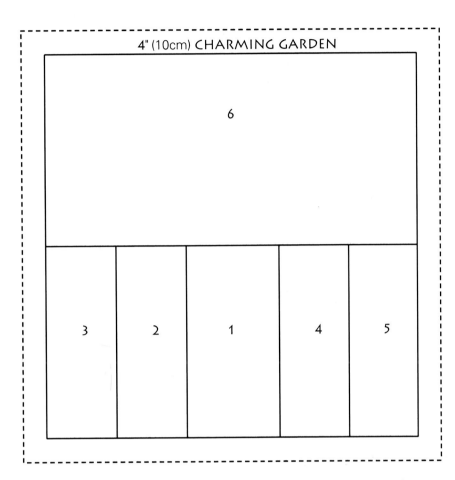

4" (10cm) CHARMING GARDEN

6

3 2 1 4 5

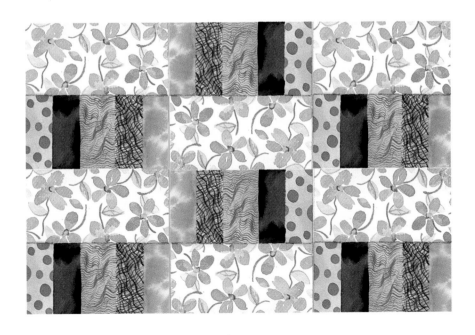

GARDEN RAMBLE

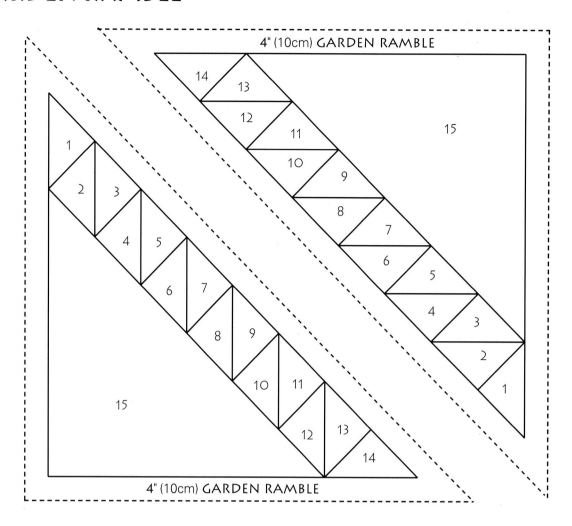

4" (10cm) GARDEN RAMBLE

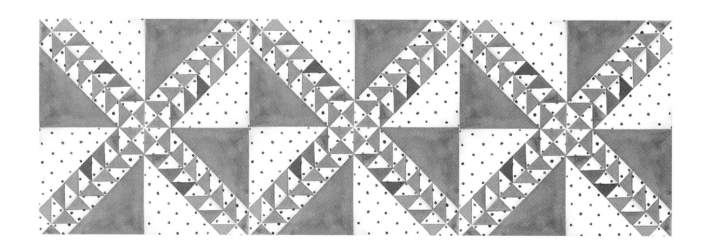

BRIGHT STARS

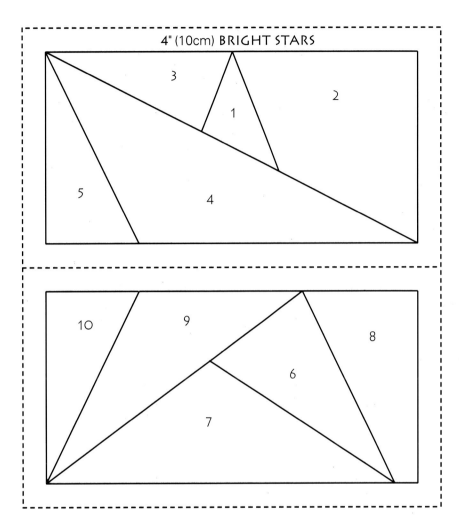

4" (10cm) BRIGHT STARS

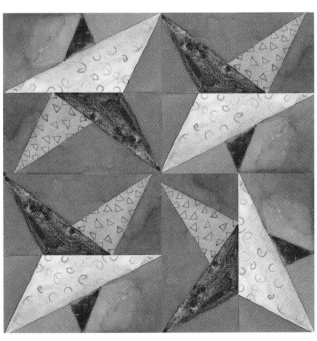

FLOWERS AND LEAVES

TALL FLOWER ◆◆◆

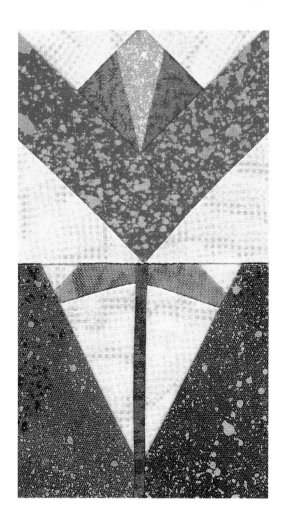

A short row of these striking flowers are all you need for a distinctive fabric garden. Be sure to use several shades of green fabric for more visual interest.

CORNER BUD ◆

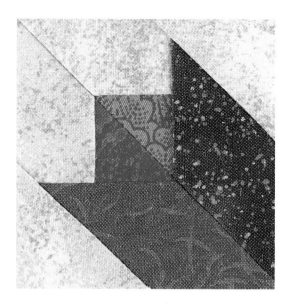

The subunits of this simple flower pattern are easy to make. Play with arranging them and see what nice geometrics they will form.

CLEMATIS BUD ◆

The sharp petals of this barely opening flower are a snap to create with this easy foundation pattern. Have fun arranging them into a bright quilted bouquet.

BELLFLOWER ♦

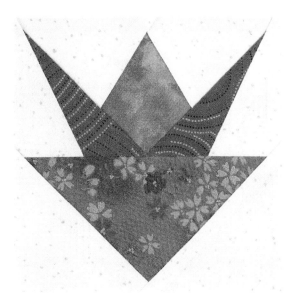

Rather fuschialike in structure, this simple flower can be made in many effective color combinations. Enjoy them in groups or singly in your fabric garden.

BIRD OF PARADISE FLOWER ♦

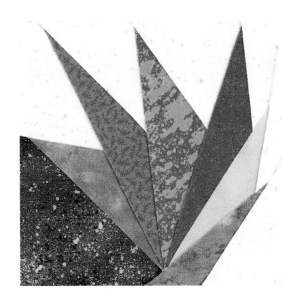

Dramatic and exotic, the bird of paradise is a showoff in any garden. Your fabric gardens need not be bound by reality—enjoy making these in exotic fabrics to brighten up the landscape.

AUTUMN LEAF ♦

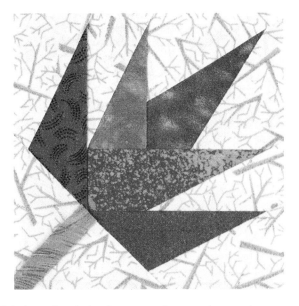

This is a simple leaf pattern that can be made very effectively in several shades or prints. Make them in spring greens or autumn's fiery shades.

CACTUS FLOWER ♦

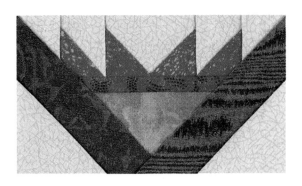

Full of prickly beauty, these small blocks will fit into your fabric gardens and give a natural order to your quilted landscapes.

CORNER ROSE ◆

This is a very easy pattern and makes many effective geometric arrangments for fabric gardens. Enjoy choosing the fabrics and designing your own variant.

WATER LILY ◆

Always a delightful surprise to find in the garden pond, these lilies can be made in all the colors of the rainbow at your whim.

POTTED PLANT ◆

Forcing flowering bulbs to bloom in the middle of winter while the outside greenery still sleeps is one way to salvage the sanity of a winterbound gardener. Have fun choosing special prints to make this beauty bloom especially for you.

SPIKE FLOWER ◆◆

This pattern offers a chance to play with shading and dimension in the flower garden. Its subunits are easy to put together for an effective display.

LEAF BUD ◆◆

These simple subunits yield satisfyingly sharp points on your leaves. Color them for spring, summer, or fall and enjoy their rich energy.

SPRING BUD ◆◆

Though I have named this for the first unfolding petals of spring, you can choose hot summer colors for another effect. Enjoy the ease foundation piecing gives for these sharp points.

SHARP LEAF ◆◆

This leaf offers lots of opportunity for playing with print textures and shading effects. Put some in amongst simpler foliage patterns and watch your quilt glow.

APPLE TREES ◆◆

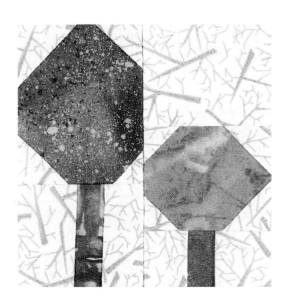

Embellish your trees with beads or French knots to enhance their fruit tree appearance or make them in dark colors for landscape drama.

TALL FLOWER

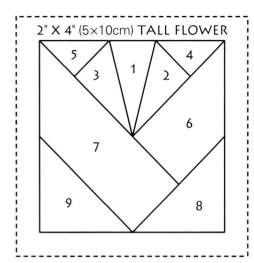

2" X 4" (5×10cm) TALL FLOWER

5
3 1 2 4
6
7
9 8

10 11
12
13
TALL FLOWER

15 14
16
17
TALL FLOWER

INSERT GREEN PIPING FOR
STEM BETWEEN SEAMS

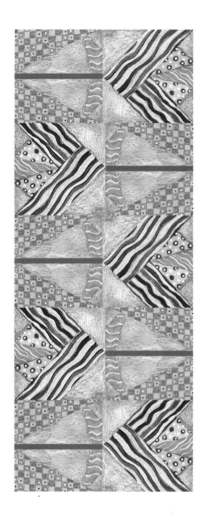

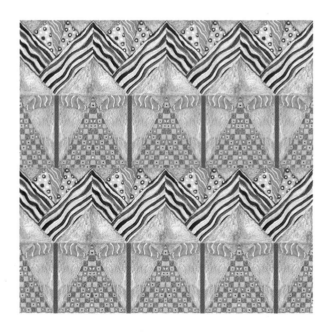

CORNER BUD

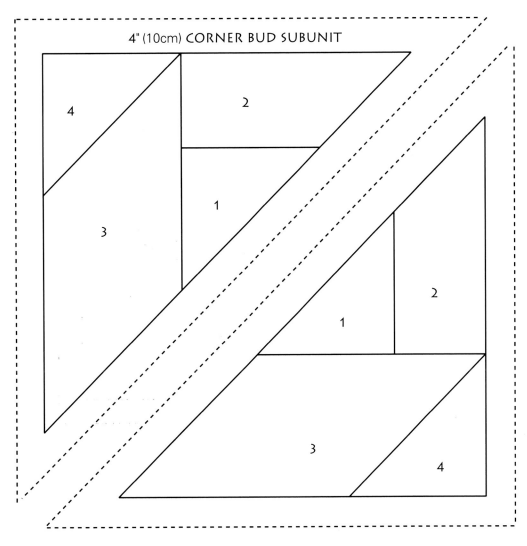

4" (10cm) CORNER BUD SUBUNIT

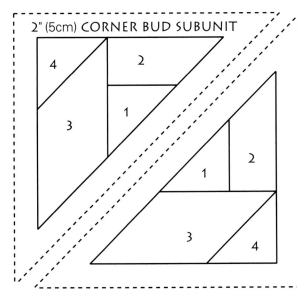

2" (5cm) CORNER BUD SUBUNIT

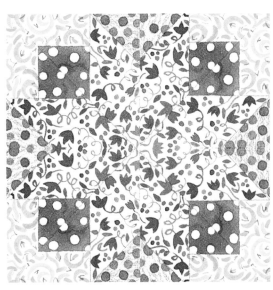

CLEMATIS BUD

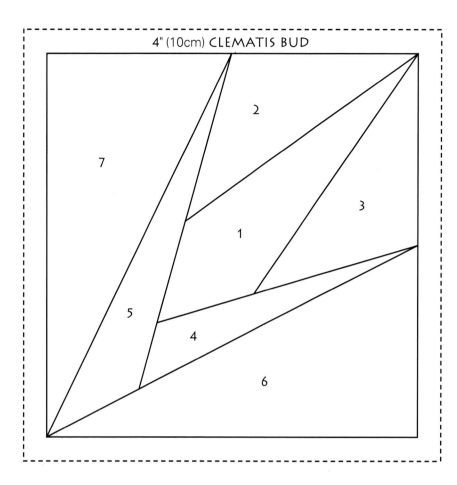

4" (10cm) CLEMATIS BUD

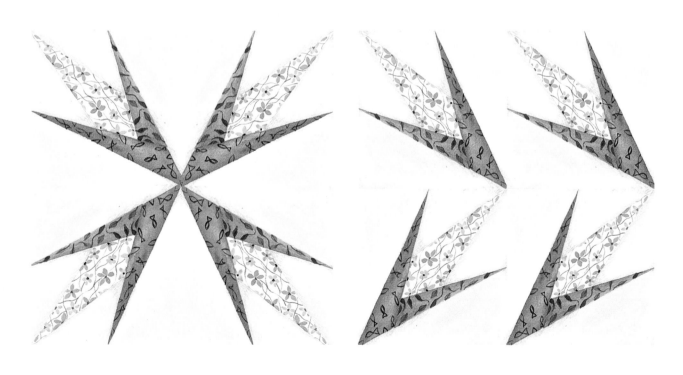

BELLFLOWER

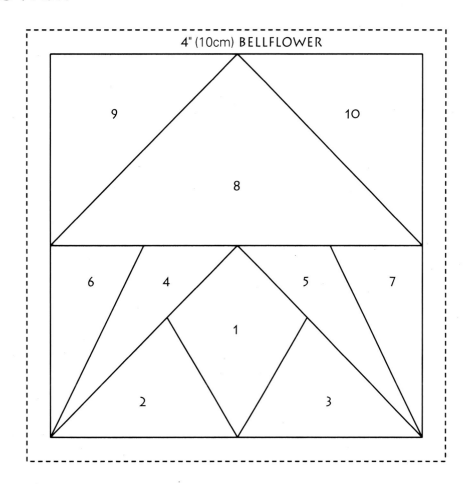

4" (10cm) BELLFLOWER

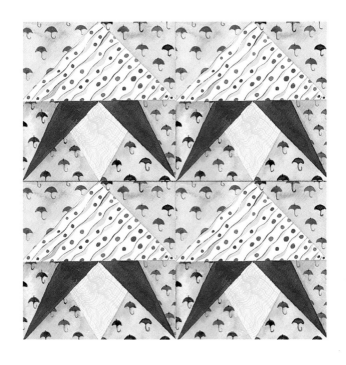

AUTUMN LEAVES

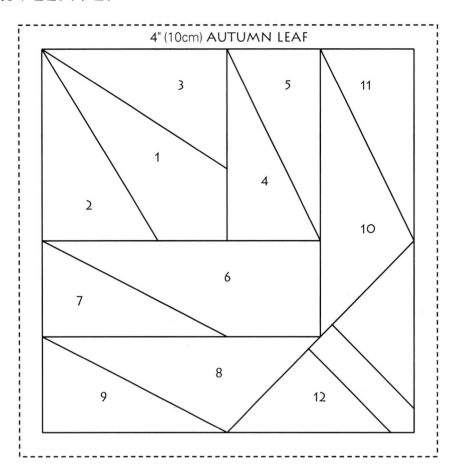

4" (10cm) AUTUMN LEAF

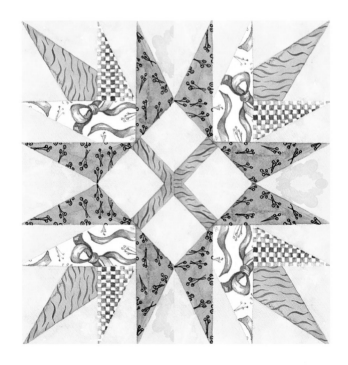

BIRD OF PARADISE FLOWER

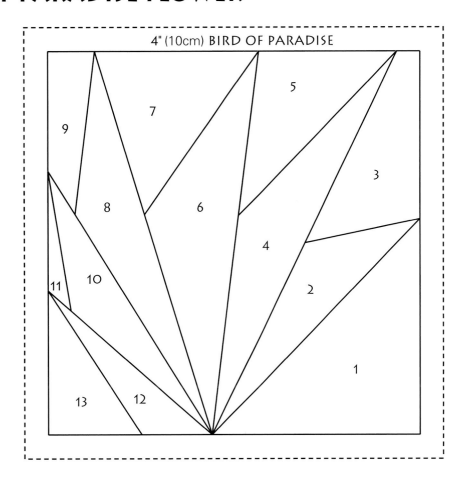

4" (10cm) BIRD OF PARADISE

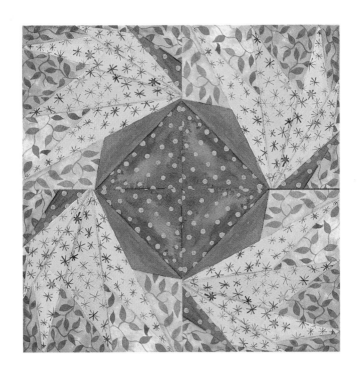

CACTUS FLOWER

2" X 4" (5×10cm) CACTUS FLOWER

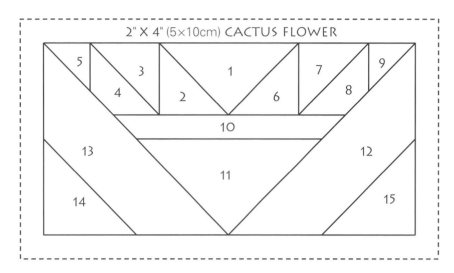

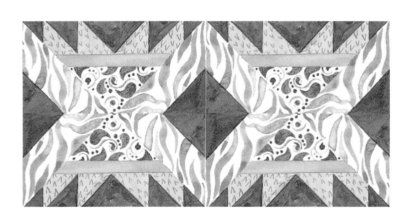

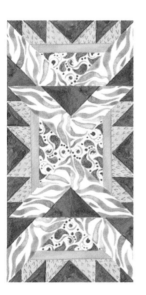

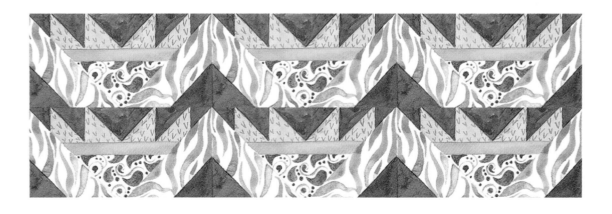

CORNER ROSE

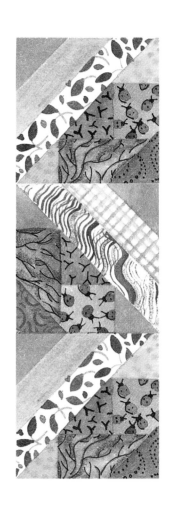

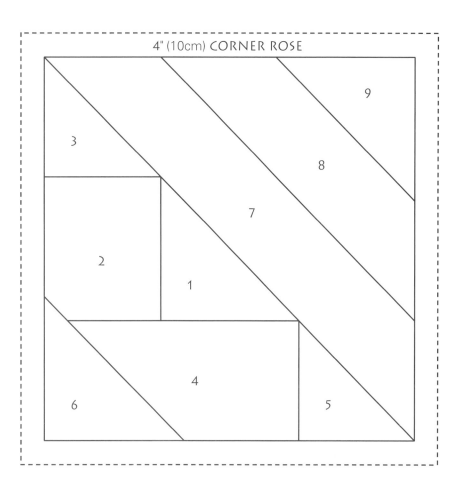

4" (10cm) CORNER ROSE

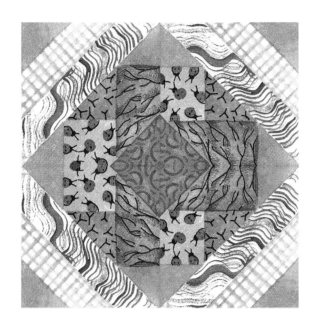

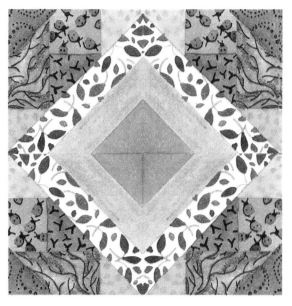

POTTED PLANT

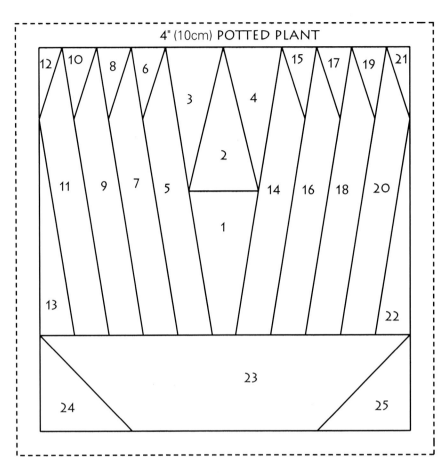

4" (10cm) POTTED PLANT

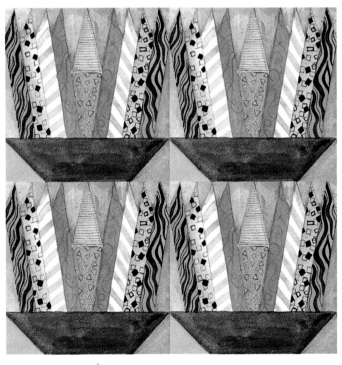

WATER LILY

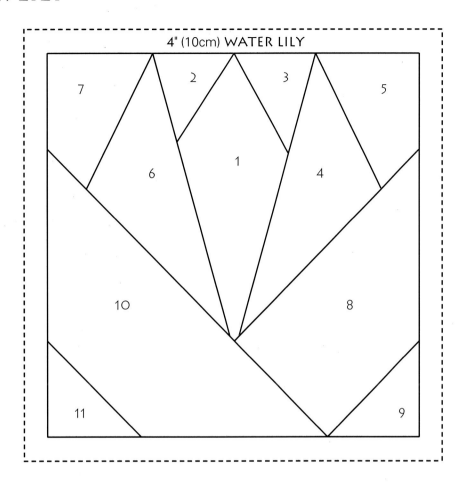

4" (10cm) WATER LILY

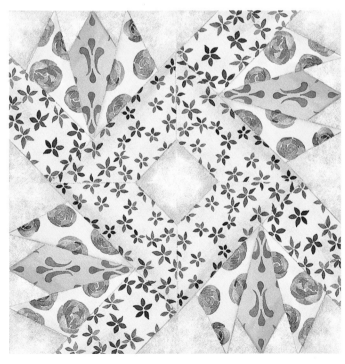

SPIKE FLOWER

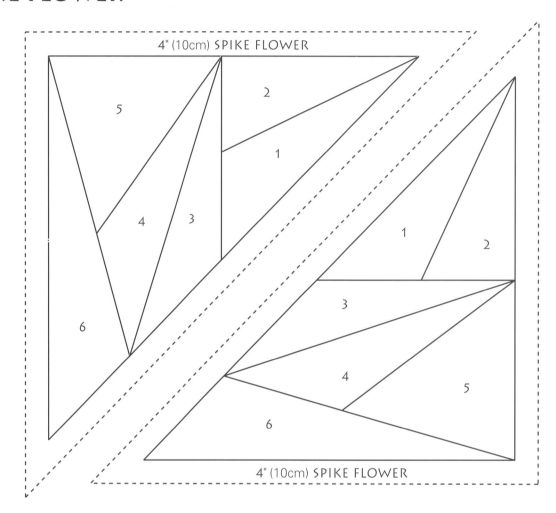

4" (10cm) SPIKE FLOWER

4" (10cm) SPIKE FLOWER

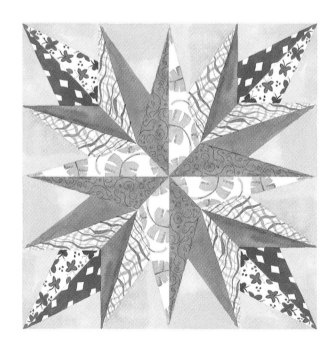

LEAF BUD

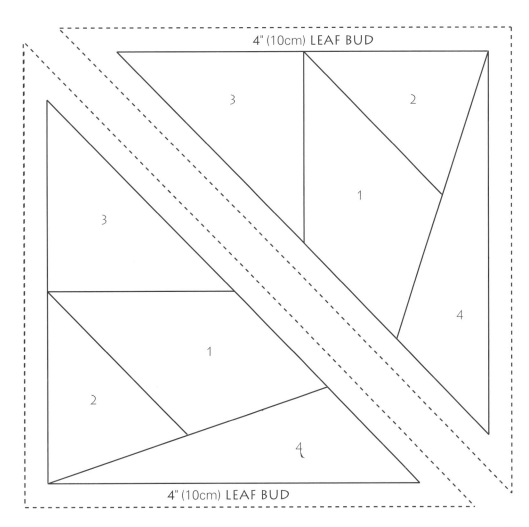

4" (10cm) LEAF BUD

3

2

1

3

4

1

2

4

4" (10cm) LEAF BUD

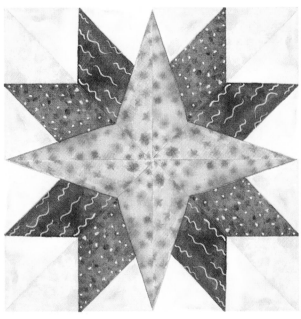

SHARP LEAF

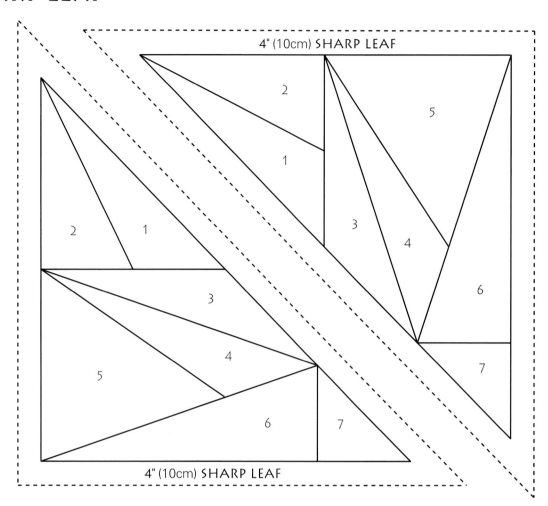

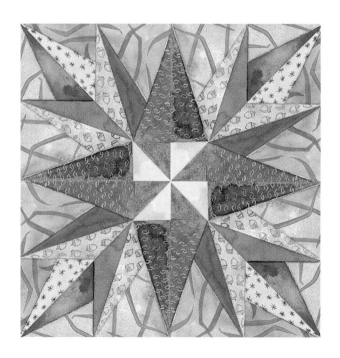

SPRING BUD

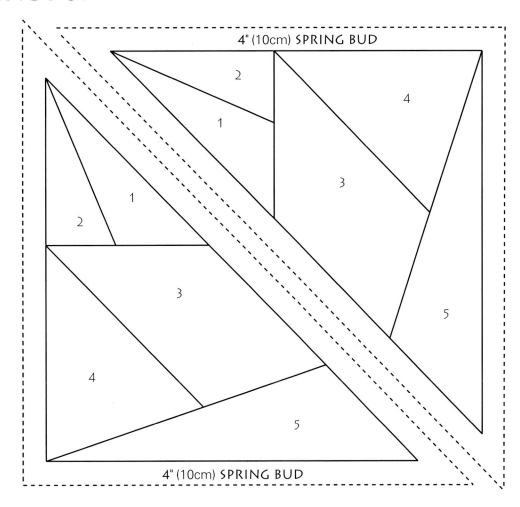

4" (10cm) SPRING BUD

4" (10cm) SPRING BUD

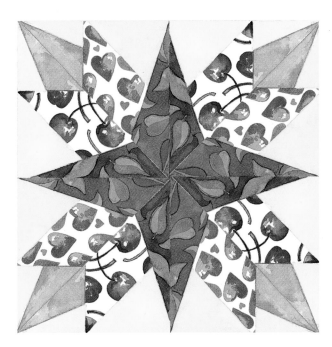

APPLE TREES

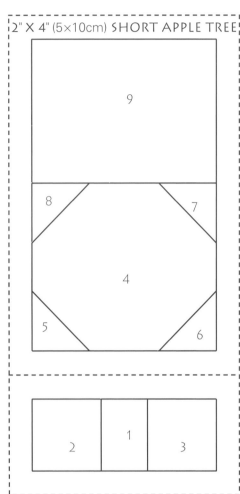
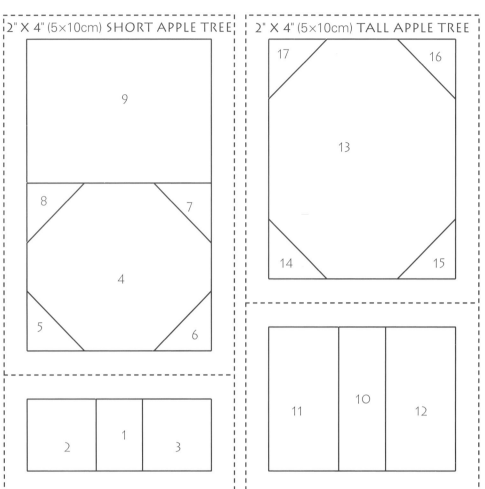

2" X 4" (5×10cm) SHORT APPLE TREE

2" X 4" (5×10cm) TALL APPLE TREE

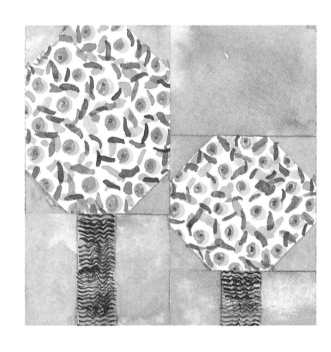

FRUITS AND VEGETABLES

PEA POD ◆

Like fresh peas picked right from the garden—
choose bright buttons for these peas, or appliqué
small circles of felt, wool, or ultrasuede.

CARROT ◆◆◆

Crisp and sweet, the first carrots of the summer—
the perfect orange print will make your mouth water.

WATERMELON ◆

Soft and sweet, watermelon is summer's best
fruit—color your watermelon red for realism and
enjoy its refreshment.

PEAR ◆◆◆

Pear fruits so luscious you can almost smell them—enjoy coloring this one in greens and yellows.

SEED PACKET ◆

Use this framing foundation to set any of these patterns, or resize the flower patterns to three-inch squares and use this block to achieve movement in your garden.

CHERRIES ◆◆◆

Fruit fresh straight from the tree—choose two different red prints to give your cherry bunch some dimensional appeal.

PEA POD

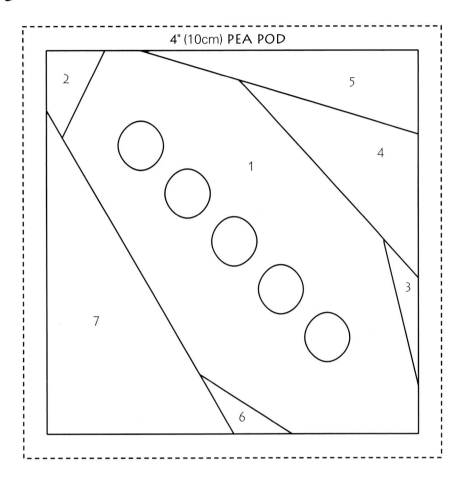

4" (10cm) PEA POD

2

5

1

4

3

7

6

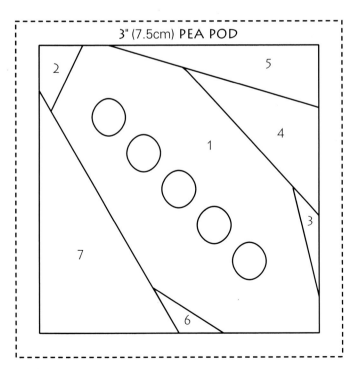

3" (7.5cm) PEA POD

2

5

1

4

3

7

6

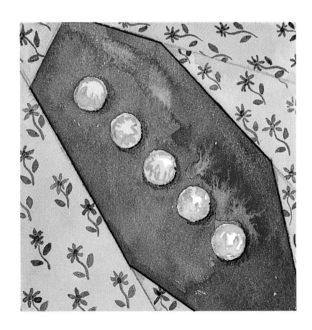

CARROT

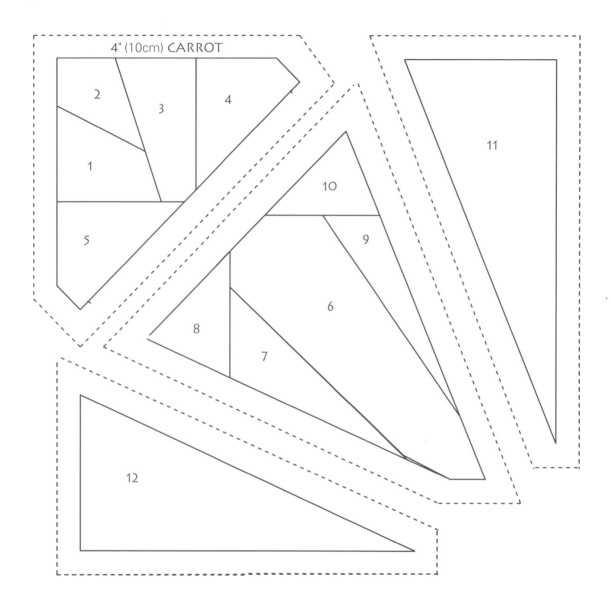

4" (10cm) CARROT

CARROT (CONTINUED)

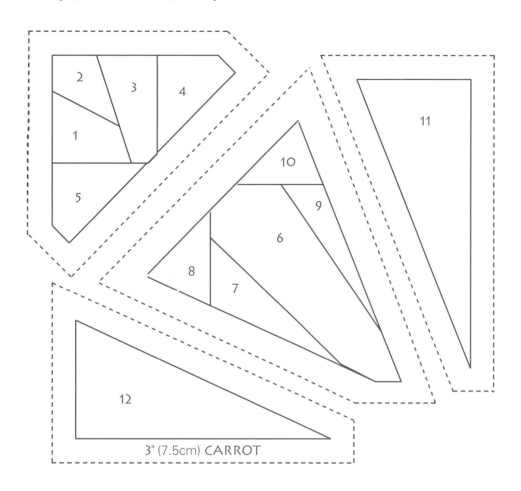

3" (7.5cm) CARROT

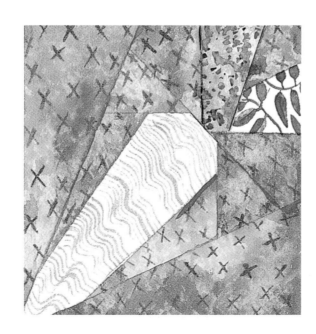

WATERMELON

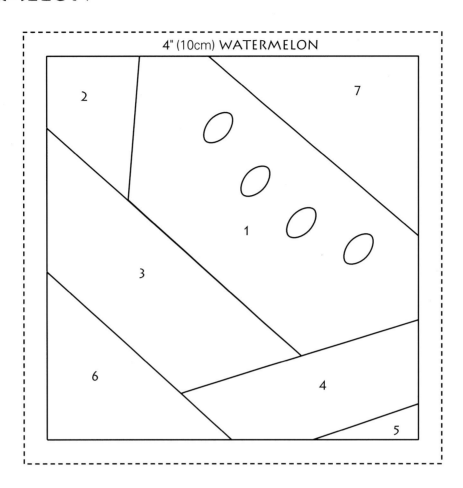

4" (10cm) WATERMELON

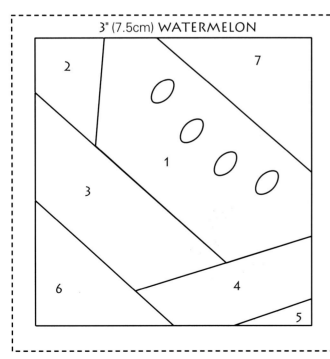

3" (7.5cm) WATERMELON

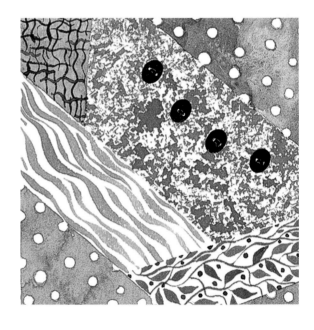

PEAR

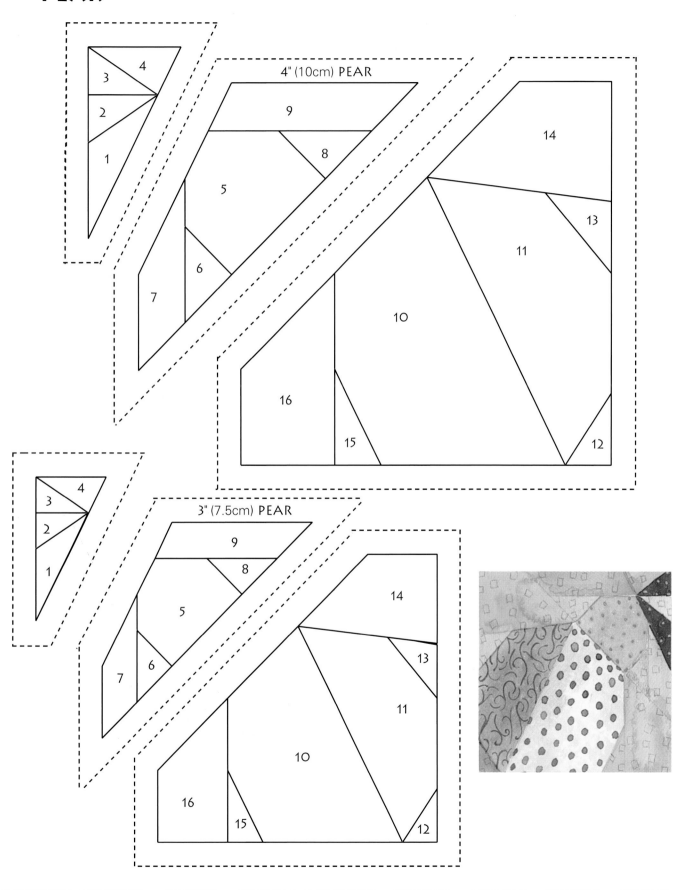

4" (10cm) PEAR

3 4
2
1

9
8
5
6
7

14
13
11
10
16
15
12

3" (7.5cm) PEAR

3 4
2
1

9
8
5
6
7

14
13
11
10
16
15
12

CHERRIES

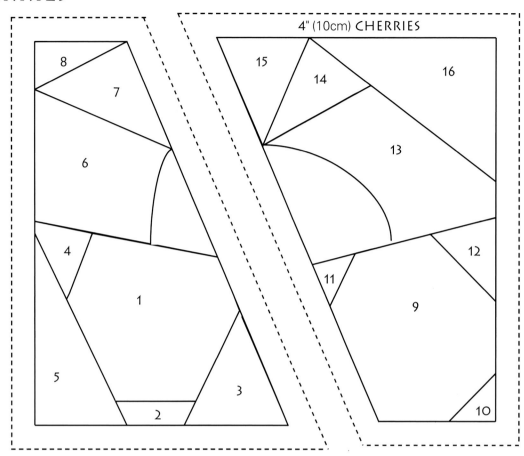

4" (10cm) CHERRIES

EMBROIDER OR INK STEMS

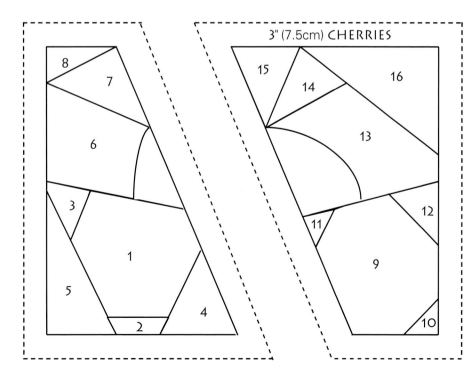

3" (7.5cm) CHERRIES

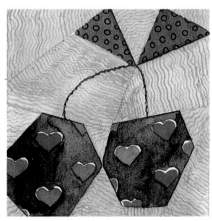

SEED PACKET

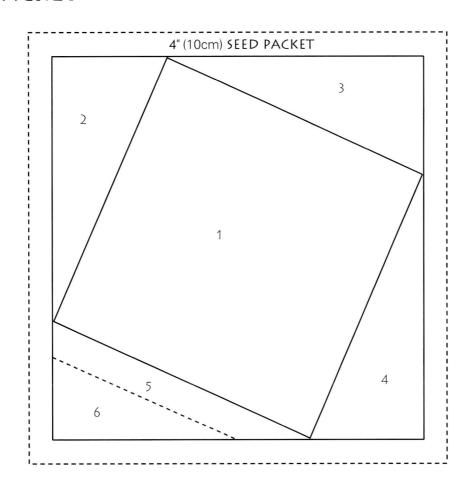

4" (10cm) SEED PACKET

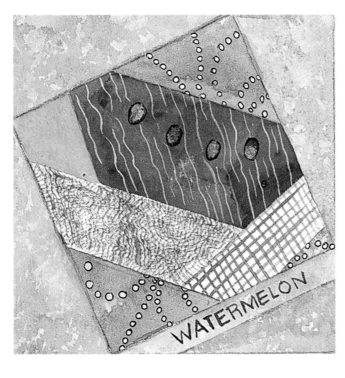

ANIMALS

BUNNY ◆◆◆

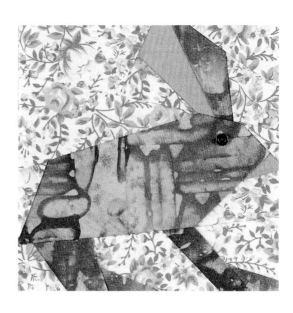

BUTTERFLY I ◆◆

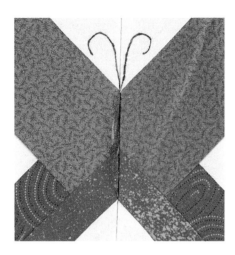

Pausing to spread its wings for your admiration, this butterfiy can be made up in any joyous fabric prints or solids. Every garden needs at least one.

Every perfect garden needs a bunny to remind the gardener how special her work really is. Use a button for your bunny's eye.

BIRD ◆◆

BUTTERFLY II ◆

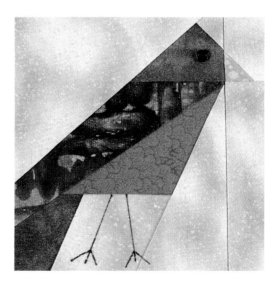

Butterflies flitting from blossom to blossom in the warm summer sun will bring peace into your fabric garden. Make them in many colors and enjoy their beauty. Draw antennae in with permanent marker.

This bird will search out beetles or grubs in your garden. Give it plumage with real colors or in festival fantasy arrays—it's your garden! Draw legs with permanent marker and use a button for the eye.

FLYING BIRD ♦♦♦

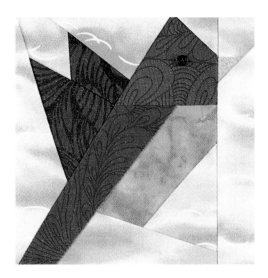

Every garden needs pert (bug eating!) wrens and bluebirds to be complete. Let this one flit around on your next fabric garden.

FISH I ♦

This fish curiously pokes into all corners of the lily pond. Give it good eyes for a more striking effect—they can be buttons, embroidery, paint, or appliqué.

GARDEN TOAD ♦♦

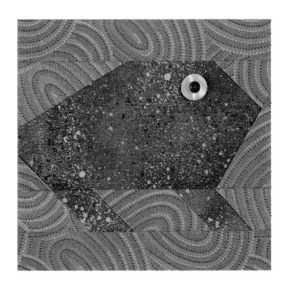

This sweet toad is so charming made up in different ways—every garden needs at least one to take care of those minor pesky insect annoyances and to bring good luck. Use a button for the eye.

FISH II ♦

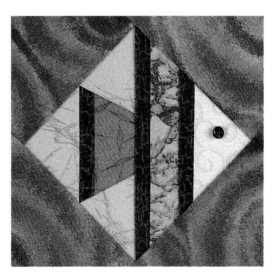

Choose the frame fabric for this fish carefully and have fun dressing it up or down with different fabrics for the stripes. A school of these flitting about the garden pond will ensure a lively effect.

BUTTERFLY I

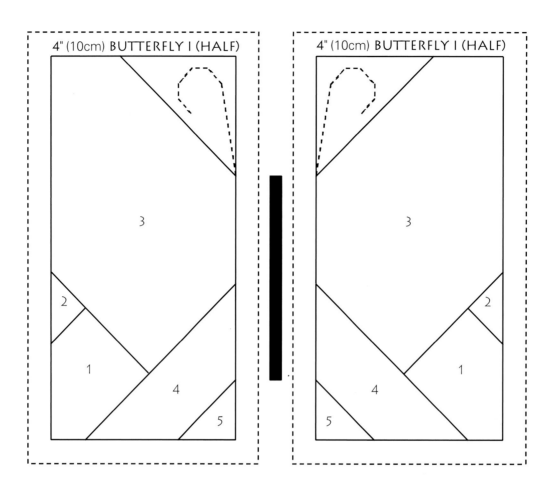

4" (10cm) BUTTERFLY I (HALF)

4" (10cm) BUTTERFLY I (HALF)

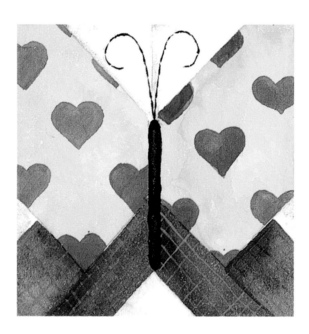

INSERT BLACK PIPING FOR BODY AS YOU SEAM TOGETHER HALVES; ANTENNAE CAN BE INKED WITH PIGMA PERMANENT PENS OR EMBROIDERED ON AFTER FOUNDATION REMOVAL

BUTTERFLY II

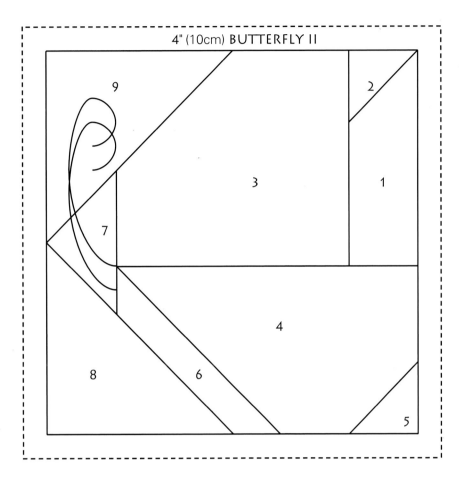

4" (10cm) BUTTERFLY II

ANTENNAE CAN BE INKED OR EMBROIDERED AFTER BLOCK ASSEMBLY

BUNNY

4" (10cm) BUNNY

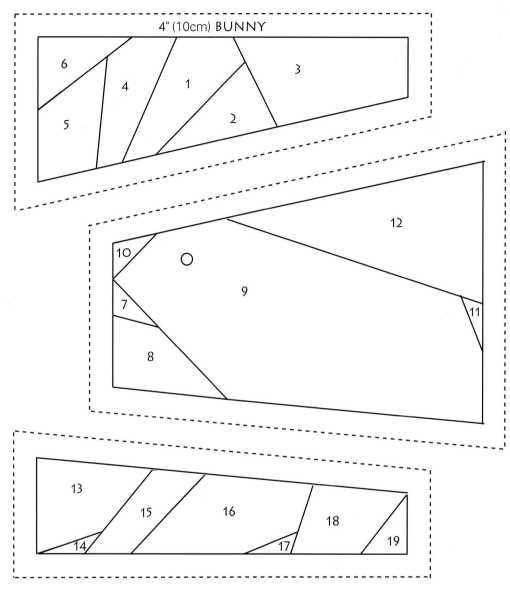

BIRD

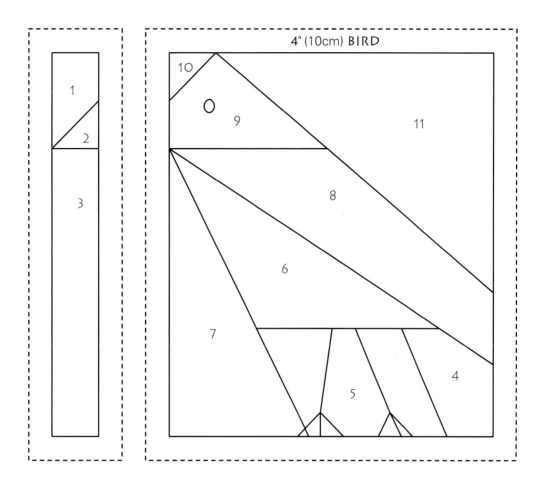

4" (10cm) BIRD

1
2
3

10
O 9
11
8
6
7
5
4

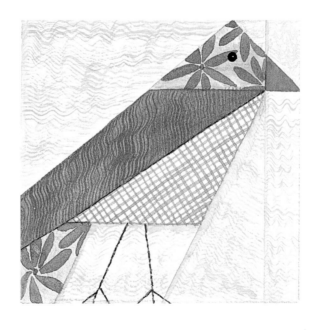

FLYING BIRD

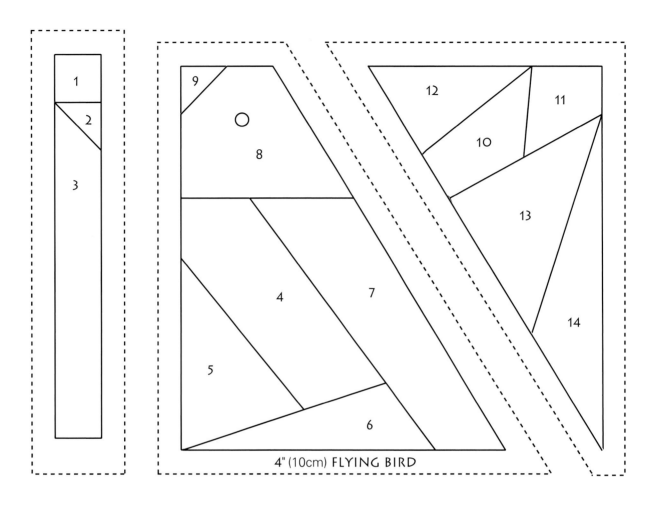

4" (10cm) FLYING BIRD

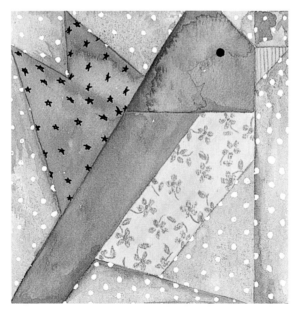

GARDEN TOAD

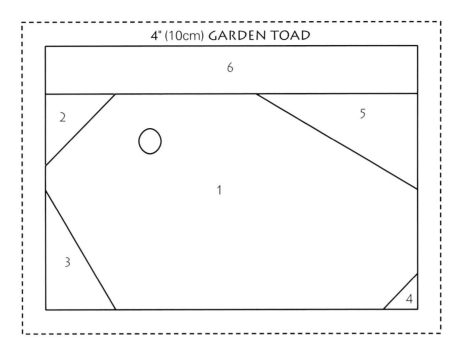

4" (10cm) GARDEN TOAD

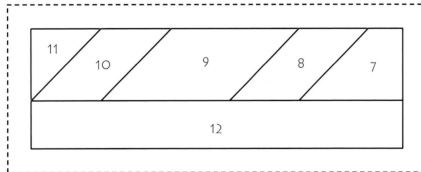

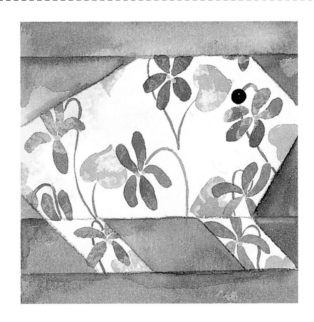

FISH I

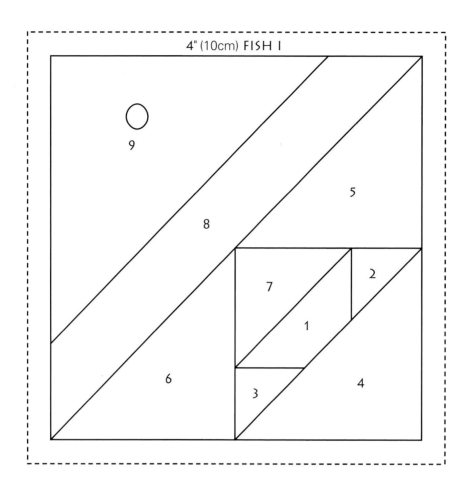

4" (10cm) FISH I

FISH II

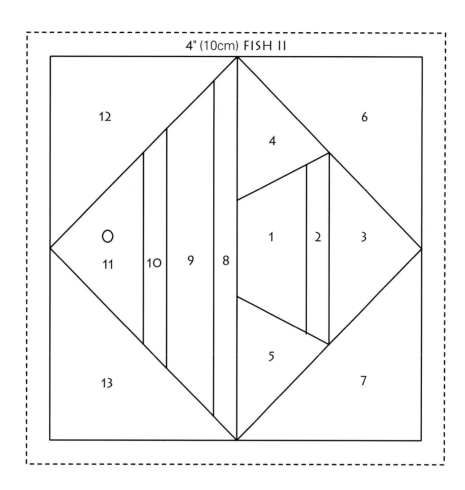

4" (10cm) FISH II

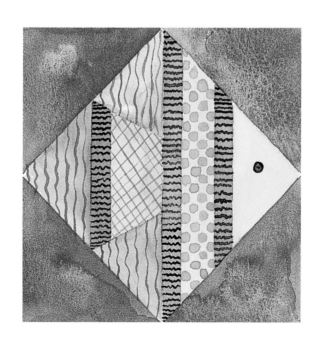

OBJECTS

JAPANESE LANTERN ◆◆

PICKET FENCE ◆

This pattern takes more work than some but yields a perfect party adornment. Enhance your fantasy-fabric get-together with a string of lights shining brightly.

Making the subunits for this fence is slightly more trouble than the other borders we have given in this book...but picket fences are appealing backdrops for romantic gardens. Choose your fabrics with pleasure for exactly the effect you want.

WHIRLIGIG ◆◆

This pattern is an adaption of a traditional block with lots of movement. Put a few of these in among your flowers for energy or make a whole quilt in a whirl.

BIRD FEEDER ◆

Keep your feeder filled with good seed and the birds will repay you with their sweet songs all summer. Have fun making this feeder as realistic or fanciful as you like.

GARDEN LIGHT ◆

Bright lanterns glowing in the twilight make for a romantic garden. Make yours in realistic or exotic fabrics to suit your fancy.

FRUIT BOWL ◆

This is a very simple pattern and will work best with an interesting background fabric. Set it on point for a more realistic effect. You can fill the basket with buttons, embroidery, or 3-D appliqué flowers.

MAY BASKET ◆

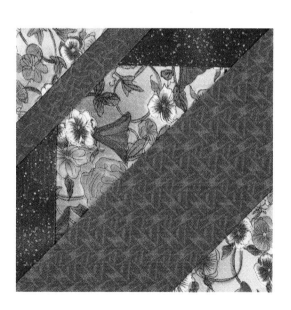

This simple traditional basket will serve for fruit or flower picking. Choose a special background print to enhance its beauty.

WATERING CAN ◆◆◆

Watering by hand is a pleasant task for the gardener. Choose a fabric you enjoy for this important gardener's standby—green to match the foliage or electric neon so you won't forget to bring it home.

BIRDHOUSE ◆◆

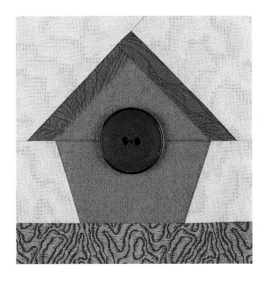

This is an easy block to make despite the need for subunit assembly. Have lots of fun choosing an assortment of fabrics for a bird city in your garden.

SPADE ◆◆

An indispensable garden tool, the spade makes a wonderful icon for the rewards of hard labor. This one will fit into the corner of your fabric garden (which needs no spadework to bloom).

JAPANESE LANTERN

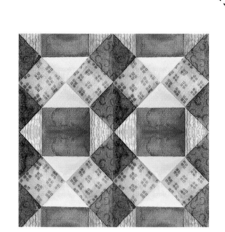

4" (10cm) JAPANESE LANTERN

4" (10cm) JAPANESE LANTERN

PICKET FENCE

2" X 4" (5×10cm) PICKET MODULE

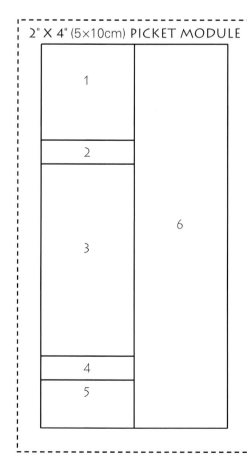

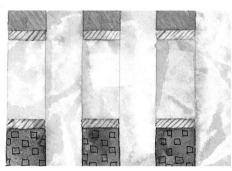

WHIRLIGIG

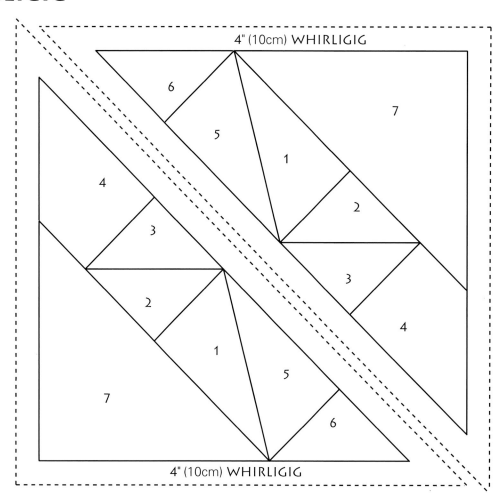

4" (10cm) WHIRLIGIG

4" (10cm) WHIRLIGIG

BIRD FEEDER

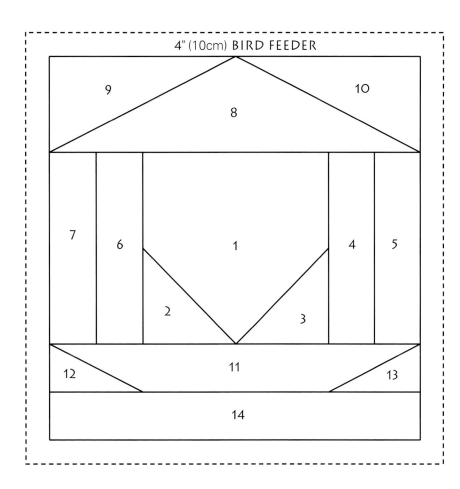

4" (10cm) BIRD FEEDER

FRUIT BOWL

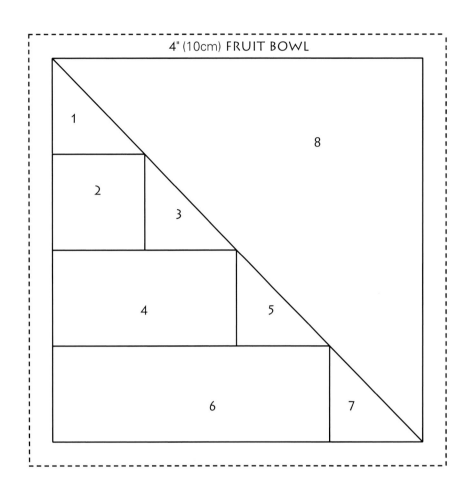

4" (10cm) FRUIT BOWL

1
2
3
4
5
6
7
8

GARDEN LIGHT

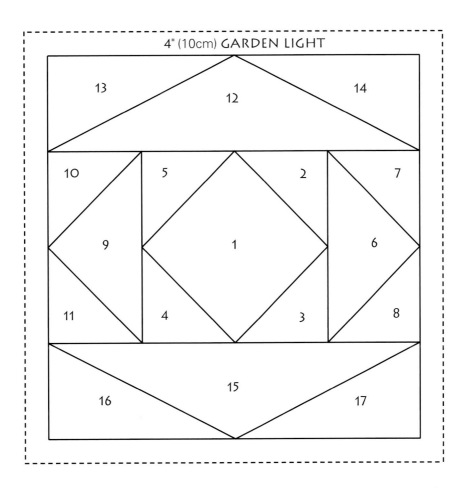

4" (10cm) GARDEN LIGHT

13 12 14
10 5 2 7
9 1 6
11 4 3 8
15
16 17

MAY BASKET

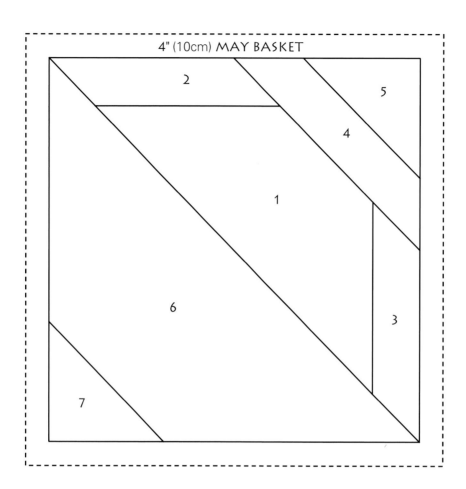

4" (10cm) MAY BASKET

WATERING CAN

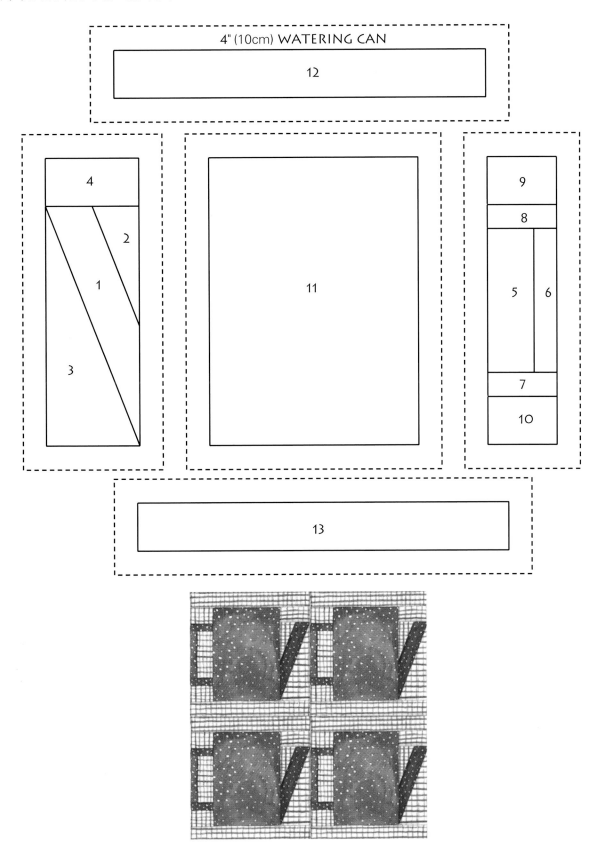

4" (10cm) WATERING CAN

12

4

2

1

3

11

9

8

5 6

7

10

13

SPADE

13

12

11

16

15

14

4" X 8" (10×20.5cm) GARDEN SPADE

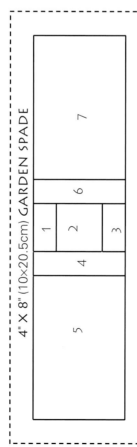

7

6

1

2

3

4

5

10

9

8

BIRDHOUSE

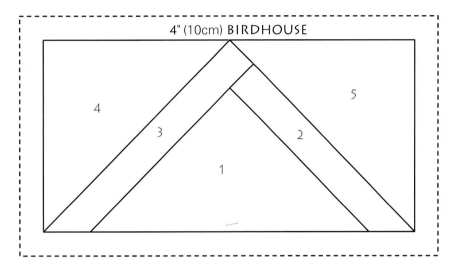

4" (10cm) BIRDHOUSE

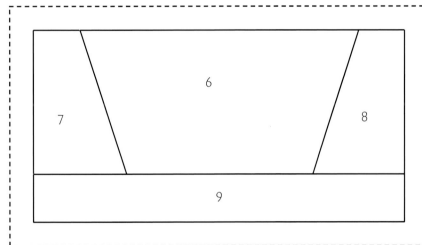

USE ¾" DIAMETER BUTTON FOR ENTRY HOLE

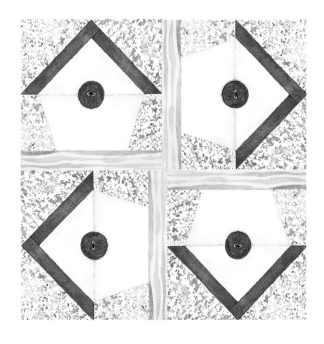

LANDSCAPES

ROAD THROUGH THE WOODS ◆

SUNRISE OVER MOUNTAIN LAKE ◆

This landscape is more elaborate than the others but still very easy to construct. Make different times of day or seasons of the year for an effective quilt.

Where does this road go? Mine heads into the hills to Grandma's house. Your fabric choices can make this a very seasonal block; maybe you would enjoy your own version of homecoming for every season of the year.

GREEN WOODS ◆

This easy block evokes woodsy walks and silent green beauty. Put several together for your own secret fabric hideaway.

THE ROAD HOME ◆

Simpler than Road Through The Woods, this block evokes family visits to the country to see loved ones. Choose an assortment of prints to make this simple block heartwarming.

LAKE IN THE MOUNTAINS ◆

This small patchwork landscape can be used effectively as a border or as part of a larger landscape quilt. Enjoy choosing just the right print for the water and sky (be sure to consider using the back side of the sky print for the water surface).

FAR AWAY VISTAS ◆

Create a simple small block of far away mountains. Remember that the farthest mountains should be colored the lightest if you want a realistic effect. These small blocks can be arranged together in many ways.

MOUNTAIN LAKE ◆

Enjoy fitting this small landscape into your larger picture. You can enhance the mountains by choosing different prints.

MOUNTAIN SUNRISE ♦

Early morning mists rising off the mountains give the air a sweet fresh tang. The energy of your landscape will be affected strongly by your choice for sun fabric—pale fabrics will give a peaceful meditative quality to the morning, bright ones will lend vibrant energy to the start of the day. Or be daring and craft a beautiful mountain sunset instead.

CORNER SUNSHINE ♦♦

From soft early morning light to hot afternoon, this pattern will give your fabric garden life and energy in scrappy oranges and yellows...or in dramatic solids.

MOUNTAINS ♦

Combine this block with far vistas to make a dramatic horizon for your garden. Experiment with mountain colors and prints.

SUNRISE OVER MOUNTAIN LAKE

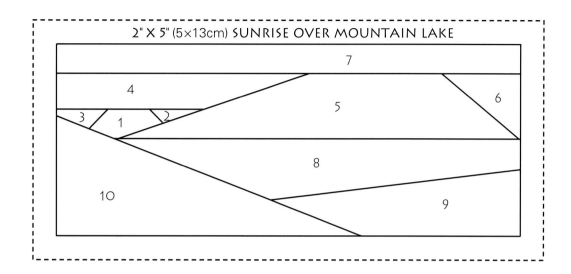

2" X 5" (5×13cm) SUNRISE OVER MOUNTAIN LAKE

GREEN WOODS

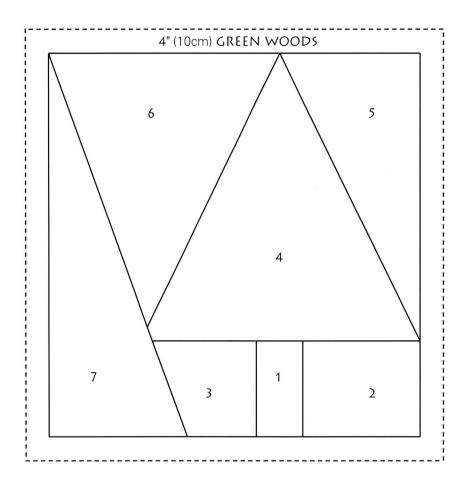

4" (10cm) GREEN WOODS

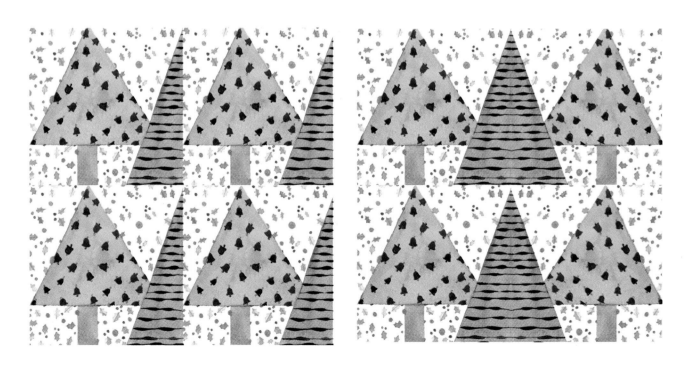

ROAD THROUGH THE WOODS

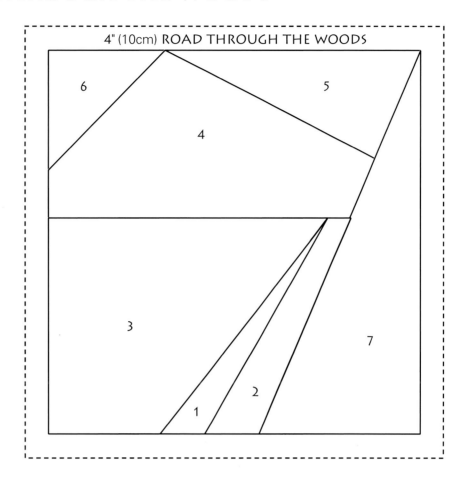

4" (10cm) ROAD THROUGH THE WOODS

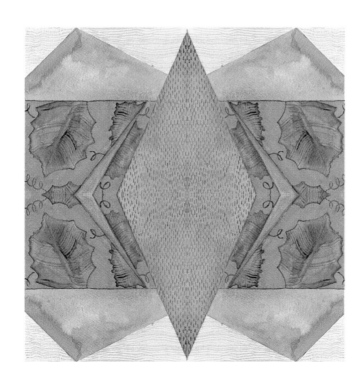

THE ROAD HOME

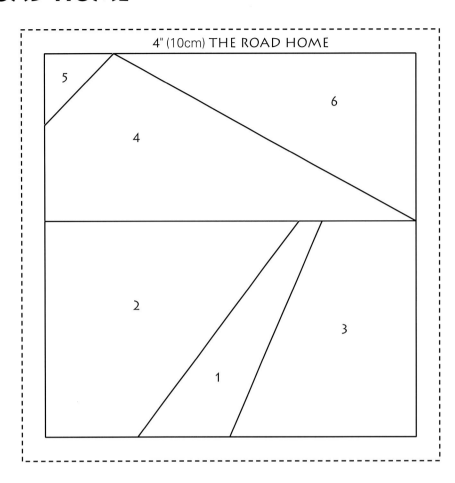

4" (10cm) THE ROAD HOME

FAR AWAY VISTAS

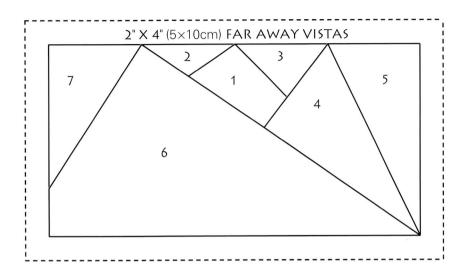

2" X 4" (5×10cm) FAR AWAY VISTAS

LAKE IN THE MOUNTAINS

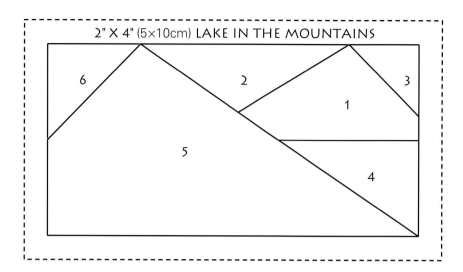

2" X 4" (5×10cm) LAKE IN THE MOUNTAINS

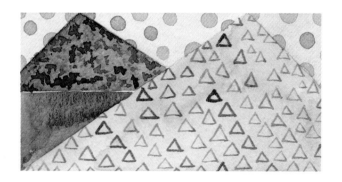

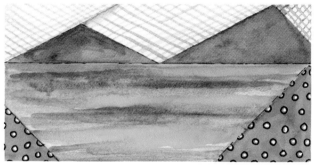

MOUNTAIN LAKE

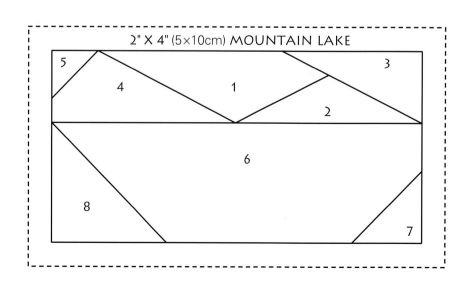

2" X 4" (5×10cm) MOUNTAIN LAKE

MOUNTAIN SUNRISE

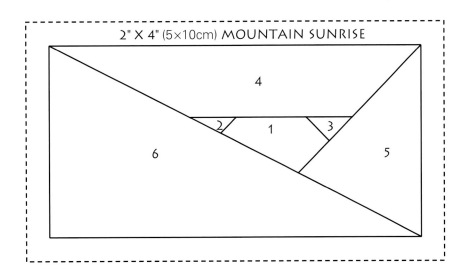

2" X 4" (5×10cm) MOUNTAIN SUNRISE

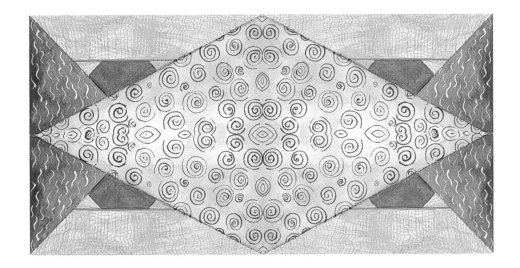

MOUNTAINS

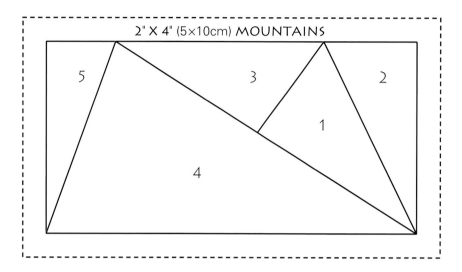

2" X 4" (5×10cm) MOUNTAINS

CORNER SUNSHINE

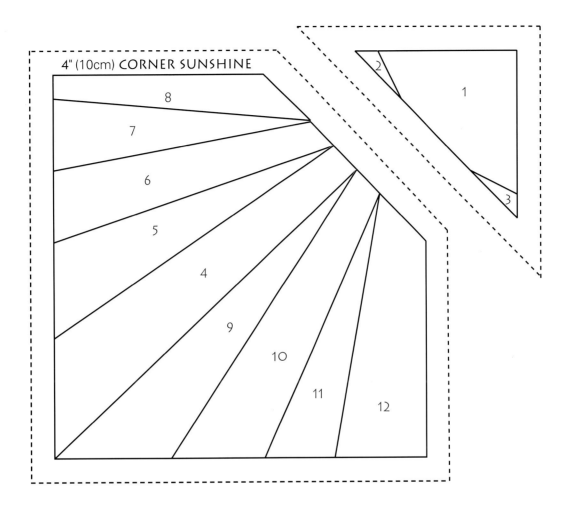

4" (10cm) CORNER SUNSHINE

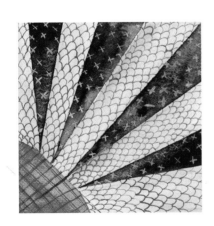

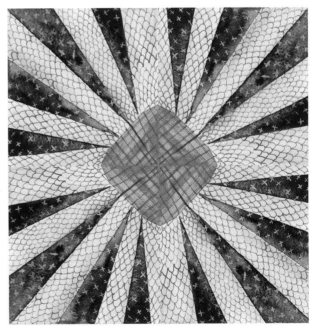

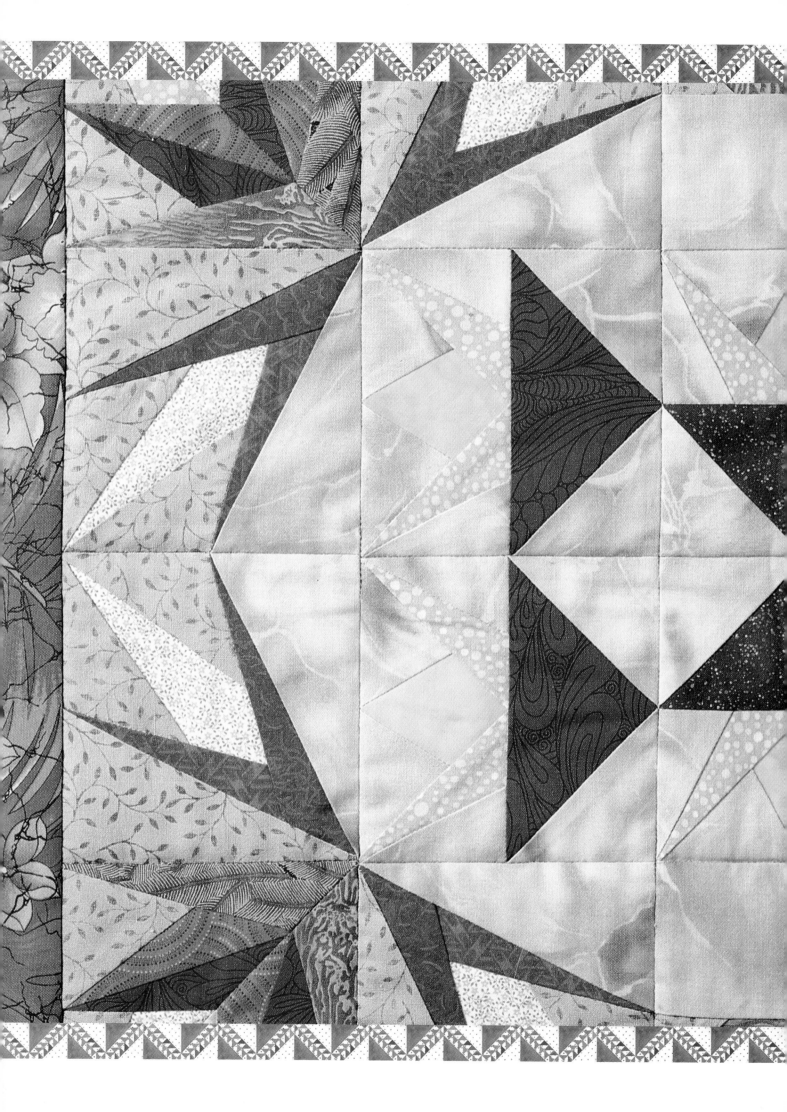

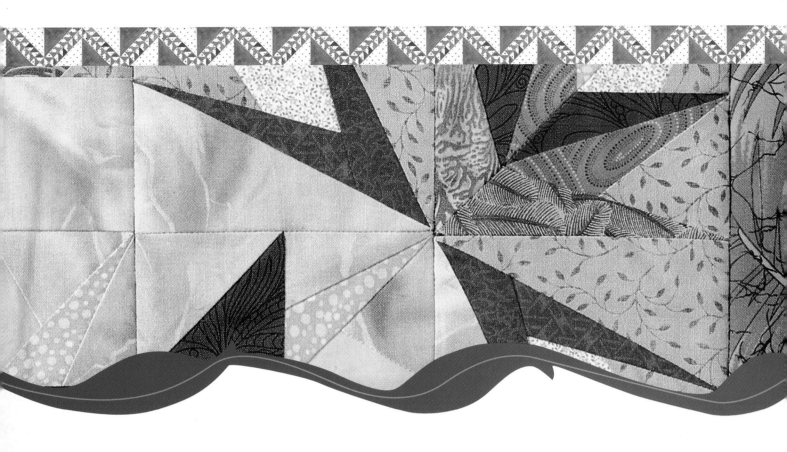

QUILT DESIGNS

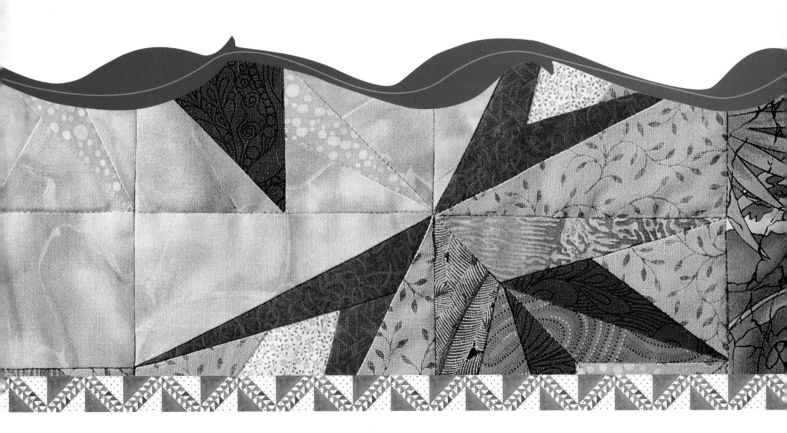

QUILT DESIGNS

Here are twelve miniature quilt designs, each using one or more of the designs from the quilt block library. Use these patterns as a starting point for your journey into foundation piecing. An easy way to begin is to choose nine blocks, make them up in coordinating fabrics, then join them to make a sampler quilt. This is a great way to try several block designs and gain proficiency at foundation piecing at the same time.

Each of Linda's quilts shows just one of the many ways the quilt design can be used. The possibilities for interpreting these designs are virtually endless.

Some of the designs lend themsleves best to a literal interpretation. Garden Plans is a perfect opportunity to use wonderful garden-themed fabrics and to piece colorful prints into edible-looking fruits and vegetables. A family of Robin Red Breasts or Bluebirds takes advantage of the generous offering of nest boxes in Garden Birds.

Foundation piecing needn't be limited to miniature quilts. You can enlarge the blocks to make a full-size quilt of eight-inch (20.5cm) blocks, and, for an even larger quilt, add more blocks to the design.

Besides its simplicity, one of the beauties of foundation piecing is the opportunity it presents to use small amounts of leftover fabrics—a scrap saver's dream come true! The quilts shown here generally require less than one-quarter yard (23cm) of any fabric; most use much less.

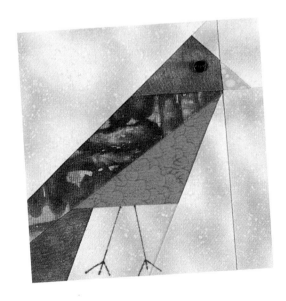

Other designs come to life with a change of color. Water Gardens is a serene underwater paradise when made up in calm colors, but it can be jazzed up with bright, busy prints. Add a few metallic prints and a dash of glitzy machine-embroidered seaweed for a contemporary embellished piece.

Picture the center on-point squares of the lanterns in Party Lights with yellow set against dark fabrics for the lanterns. As an alternative, turn this quilt into a graphic rather than a pictorial design: use the lanterns as shapes instead of objects by having less of a contrast between the two fabrics.

Another direction to take is the traditional route. Good Morning Sunshine makes an excellent scrap quilt. Reds, oranges, and yellows for the Corner Sunshine and Thorny Trail blocks juxtaposed against green will make the sun shine right off the quilt. The idea of a scrappy look is traditional, while the finished effect is thouroughly modern when using yellows and reds!

To test your fabric choices for a quilt design, make up a block or glue fabric to a copy of each block design and make color copies. You can then put these together to see exactly what the quilt will look like before you sew the remaining blocks.

Fabric usage can vary depending upon cutting efficiency, so be sure to purchase a little extra fabric. Remaining yardage can be used as binding or be pieced together to make interesting quilt backings.

Note that some of the block designs have been flipped in some of the quilts, creating a reverse image, like the large central green woods blocks in the Woodlands quilt.

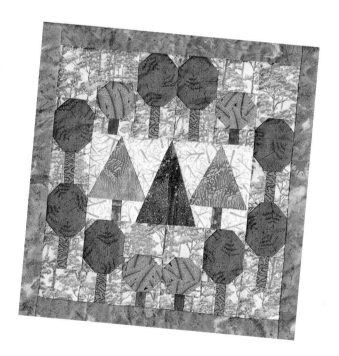

ROSE STAR

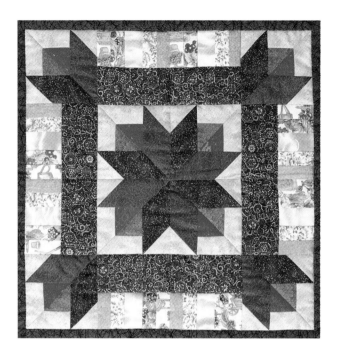

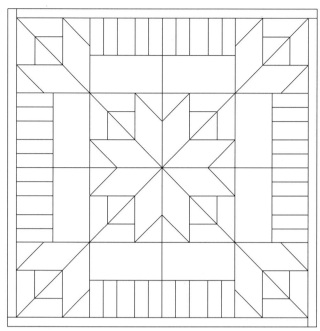

FINISHED SIZE: 17" × 17" (43 × 43cm)

FABRIC REQUIREMENTS:

 BLOCKS: Scraps of fabric for pieced blocks

 BORDER: 4" (10cm) strips each 1" × 17"

 (2.5 × 43cm)

 BACKING: 22" × 22" (56 × 56cm)

 BATTING: 21" × 21" (53.5 × 53.5cm)

◆ **CORNER BUD (page 45)**

 4" (10cm) block size

 Make 8

◆ **CHARMING GARDEN (page 37)**

 4" (10cm) block size

 Make 8

This quilt is a good choice for a beginner.

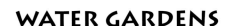

WATER GARDENS

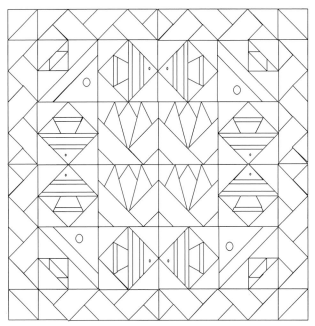

FINISHED SIZE: 20" × 20" (51 × 51cm)

FABRIC REQUIREMENTS:

 BLOCKS: Scraps of fabric for pieced blocks and border blocks

 BACKING: 24" × 24" (61 × 61cm)

 BATTING: 24" × 24" (61 × 61cm)

◆ **FISH I (page 76)**

 4" (10cm) block size

 Make 4

◆ **FISH II (page 77)**

 4" (10cm) block size

 Make 8 (reverse 4)

◆ **WATER LILY (page 53)**

 4" (10cm) block size

 Make 4

◆ **TWISTED RIBBON BORDER (page 26)**

 2" (5cm) block size

Make 2 to finish 16" (40.5cm) long

Make 2 to finish 18" (45.5cm) including corner

 blocks at each end for top and bottom.

Enlarge pattern 200 percent.

GARDEN BIRDS

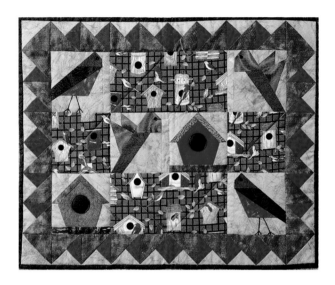
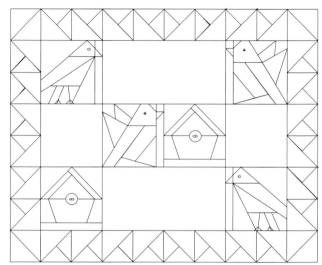

FINISHED SIZE: 16" × 20" (40.5 × 51cm)

FABRIC REQUIREMENTS:

> **BLOCKS:** Scraps of fabric for birdhouse blocks
>
> **PLAIN SQUARES:** Two 4½" × 4½" (11.5 × 11.5cm)
>
> **PLAIN RECTANGLES:** Two 4½" × 8½" (11.5 × 21.5cm)
>
> **BORDER:** Scraps of three fabrics cut in 3" (7.5cm) wide strips
>
> **BACKING:** 20" × 24" (51 × 61cm)
>
> **BATTING:** 20" × 24" (51 × 61cm)

♦ **BIRD (page 73)**

> 4" (10cm) block size
>
> Make 2 (reverse 1)

♦ **FLYING BIRD (page 74)**

> 4" (10cm) block size
>
> Make 2 (reverse 1)

♦ **BIRDHOUSE (page 89)**

> 4" (10cm) block size
>
> Make 2

♦ **FENCE TOP BORDER (page 25)**

> 2" (5cm) block size

Make 2 to finish 12" (30cm) long

Make 2 to finish 20" (51cm) long (including corner blocks)

Use birdhouse theme fabric for the plain squares and rectangles.

GARDEN PLANS

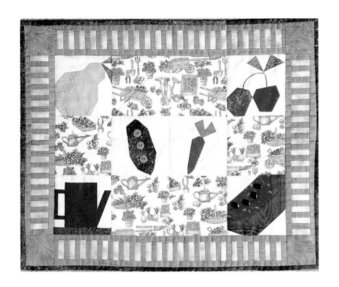

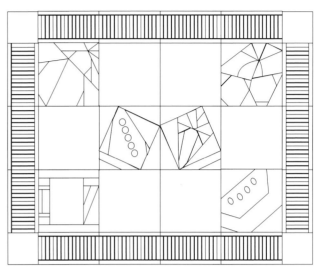

FINISHED SIZE: 16" × 20" (40.5cm × 51cm)

FABRIC REQUIREMENTS:

 BLOCKS: Scraps of fabric for pieced blocks

 Six 4½" (11.5cm) squares of garden theme fabric

 BORDER: 3" (7.5cm) wide strips of two fabrics

 Four 2½" (6.5cm) squares for corner blocks

 BACKING: 20" × 24" (51 × 61cm)

 BATTING: 20" × 24" (51 × 61cm)

♦ **PEAR (page 65)**

 4" (10cm) block size

 Make 1

♦ **CHERRIES (page 66)**

 4" (10cm) block size

 Make 1

♦ **PEA POD (page 61)**

 4" (10cm) block size

 Make 1

♦ **CARROT (page 62–63)**

 4" (10cm) block size

 Make 1

♦ **WATERING CAN (page 87)**

 4" (10cm) block size

 Make 1

♦ **LATTICE FENCE BORDER (page 27)**

 2" (5cm) block size

Make 2 to finish 12" (30cm) long

Make 2 to finish 20" (51cm) long (including plain

 corner blocks at each end)

 The two center blocks are 2" (5cm) versions of
the snap pea and carrot blocks inside seed packet
blocks (page 67). Alternatively make the vegetable
blocks in 4" (10cm) size.

 Use garden theme fabric for the plain squares.

GOOD MORNING SUNSHINE

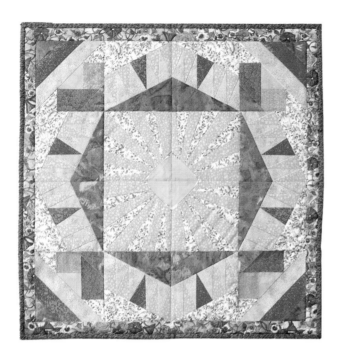

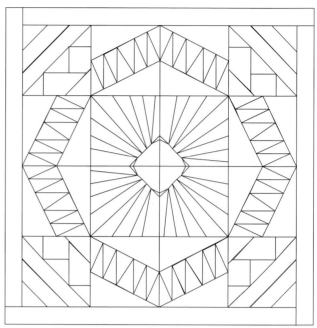

FINISHED SIZE: 18" × 18" (45.5 × 45.5cm)

FABRIC REQUIREMENTS:

 BLOCKS: Scraps of fabric

 BORDER: Four strips each cut 1½" × 17½"

 (4 × 45cm)

 BACKING: 22" × 22" (56 × 56cm)

 BATTING: 22" × 22" (56 × 56cm)

♦ **CORNER ROSE (page 51)**

 4" (10cm) block size

 Make 4

♦ **THORNY TRAIL (page 35)**

 4" (10cm) block size

 Make 8

♦ **CORNER SUNSHINE (page 101)**

 4" (10cm) block size

 Make 4

This pattern works up well as a scrap quilt of many different fabrics.

LEAFY RAMBLE

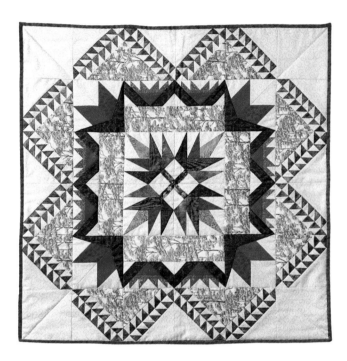

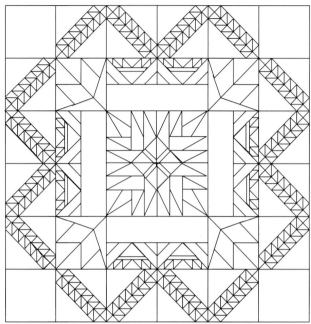

FINISHED SIZE: 24" × 24" (61 × 61cm)

FABRIC REQUIREMENTS:

BLOCKS: Scraps of fabric for pieced blocks

For small triangles cut strips 2½" (6.5cm) wide

Four 4½" × 4½" (11.5 × 11.5cm) squares for plain
 corner blocks

BORDER: Scraps of three fabrics cut in
 3" (7.5cm) wide strips

BACKING: 28" × 28" (71 × 71cm)

BATTING: 28" × 28" (71 × 71cm)

♦ **GARDEN RAMBLE (page 38)**

 4" (10cm) block size

 Make 16

♦ **LEAF BUD (page 55)**

 4" (10cm) block size

 Make 4

♦ **CACTUS FLOWER (page 50)**

 2" × 4" (5 × 10cm) block size

 Make 8

♦ **AUTUMN LEAVES (page 48)**

 4" (10cm) block size

 Make 4

Add a 4½" × 2½" (11.5 × 6.5cm) strip of fabric to
the bottom of each pieced rectangular block to make
a 4" (10cm) finished square.

PARTY LIGHTS

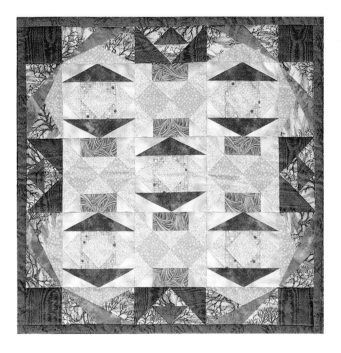

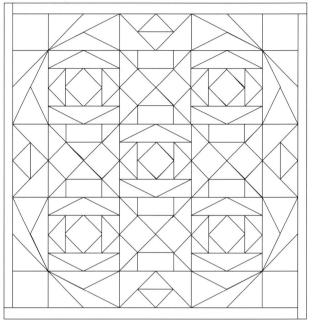

FINISHED SIZE: 18" × 18" (45.5 × 45.5cm)

FABRIC REQUIREMENTS:

 BLOCKS: Scraps of fabric for pieced blocks

 For small triangles cut strips 2½" (6.5cm) wide

 Four 2½" (6.5cm) squares for corner blocks

 BORDER: 4 strips each 1" × 17½" (2.5 × 45cm)

 BACKING: 22" × 22" (56 × 56cm)

 BATTING: 22" × 22" (56 × 56cm)

◆ **GARDEN PARTY (page 34)**

 2" × 4" (5 × 10cm) block size

 Make 8 (reverse 4)

◆ **GARDEN PATH (page 33)**

 4" (10cm) block size

 Make 4

◆ **GARDEN LIGHT (page 85)**

 4" (10cm) block size

 Make 5

◆ **JAPANESE LANTERN (page 81)**

 4" (10cm) block size

 Make 4

Design your own quilt by substituting blocks of your choice for the nine blocks in the center of the quilt.

SUMMER AFTERNOON

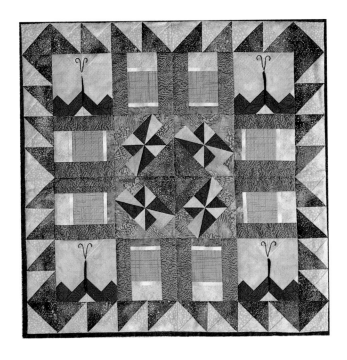

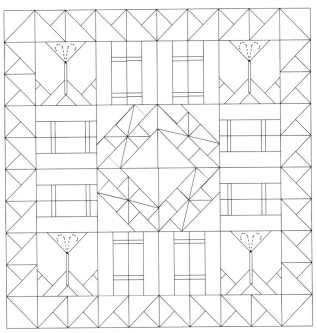

FINISHED SIZE: 20" × 20" (51 × 51cm)

FABRIC REQUIREMENTS:

 BLOCKS: Scraps of fabric

 BACKING: 24" × 24" (61 × 61cm)

 BATTING: 24" × 24" (61 × 61cm)

♦ **BUTTERFLY I (page 70)**

 4" (10cm) block size

 Make 4

♦ **PICKET FENCE (page 81)**

 2" × 4" (5 × 10cm) block size

 Make 8

♦ **WHIRLIGIG (page 82)**

 4" (10cm) block size

 Make 4

♦ **FENCE TOP BORDER (page 81)**

 2" (5cm) block size

Make 2 to finish 14" (35.5cm) long for sides

FLOWER GARDEN

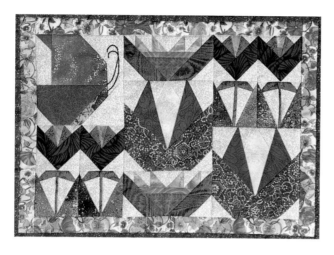 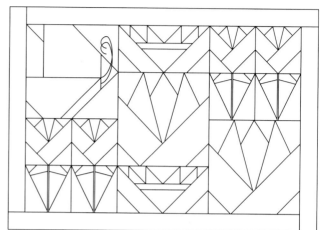

FINISHED SIZE: 13½" × 9½" (34.5 × 24cm)

FABRIC REQUIREMENTS:

> **BLOCKS:** Scraps of fabric
>
> **BORDER:** Two strips each 1¼" × 9¼"
>
> (3.5 × 23.5cm) for sides
>
> Two strips each 1¼" × 13¼" (3.5 × 33.5cm) for
>
> top and bottom
>
> **BACKING:** 18" × 14" (45.5 × 35.5cm)
>
> **BATTING:** 18" × 14" (45.5 × 35.5cm)

◆ **BUTTERFLY II (page 71)**

> 4" (10cm) block size

◆ **CACTUS FLOWER (page 50)**

> 2" × 4" (5 × 10cm) block size

◆ **TALL FLOWER (page 44)**

> 4" (10cm) block size

◆ **WATER LILY (page 53)**

> 4" (10cm) block size

Embroider the antennae or draw in with permanent marker.

TROPICAL PARADISE

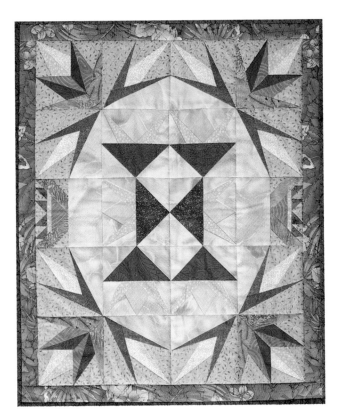

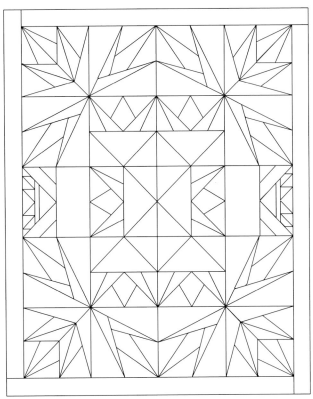

FINISHED SIZE: 18" × 22" (45.5 × 56cm)

FABRIC REQUIREMENTS:

 BLOCKS: Scraps of fabric

 BORDER: Two strips each 1½" × 17½"
 (4 × 45cm) for sides

 Two strips each 1½" × 21½" (4 × 53.5cm) for
 top and bottom

 BACKING: 22" × 26" (56 × 66cm)

 BATTING: 22" × 26" (56 × 66cm)

♦ **SPIKE FLOWER (page 54)**

 4" (10cm) block size

 Make 4

♦ **CLEMATIS BUD (page 46)**

 4" (10cm) block size

 Make 8

♦ **CACTUS FLOWER (page 50)**

 2" × 4" (5 × 10cm) block size

 Make 2

♦ **BELLFLOWER (page 47)**

 4" (10cm) block size

 Make 6

Add a 2½" × 4½" (4 × 11.5cm) rectangle to the
bottom of each pieced rectangular cactus flower
block to make a 4" (10cm) finished square.

WOODLANDS

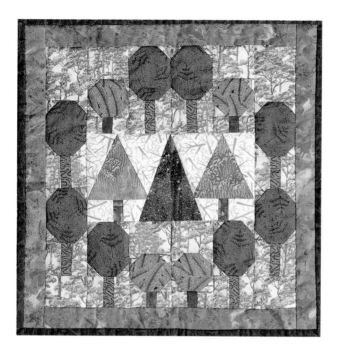

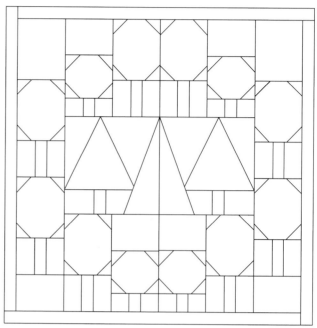

FINISHED SIZE: 14" × 14" (35.5 × 35.5cm)

FABRIC REQUIREMENTS:

BLOCKS: Scraps of fabric

Two 2½" × 3" (6.5 × 7.5cm) rectangles and four

2" × 2½" (5 × 6.5cm) rectangles for plain blocks

BORDER: Four strips each 1½" × 13½"

(4 × 34.5cm)

BACKING: 22" × 22" (56 × 56cm)

BATTING: 22" × 22" (56 × 56cm)

♦ **APPLE TREES (page 58)**

Make 8 tall tree blocks

Make 4 small tree blocks

♦ **GREEN WOODS (page 94)**

4" (10cm) block size

Make 2 (reverse 1)

To put the quilt top together, stitch the apple trees and plain blocks strips for the two sides. Sew the center apple trees together for top and bottom, then stitch the two sections to the green woods. Add the apple tree side strips.

MOUNTAIN SEASONS

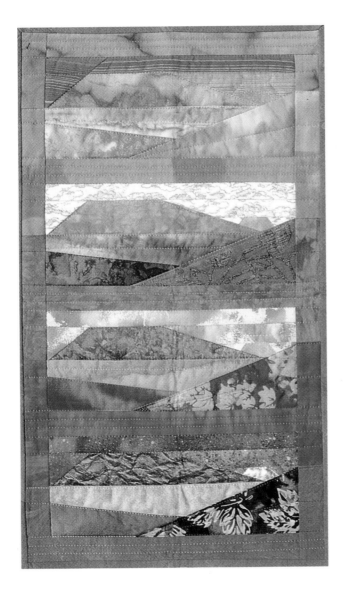

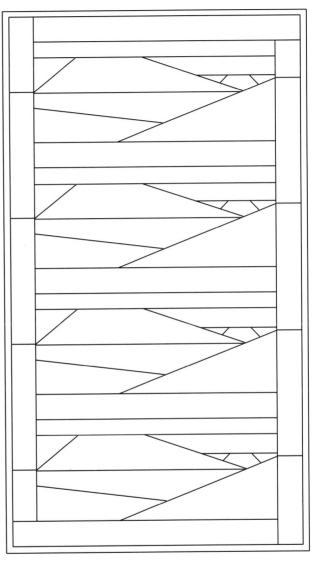

FINISHED SIZE: 12" × 21" (30.5 × 53.5cm)

FABRIC REQUIREMENTS:

 BLOCKS: Scraps of fabric

 BORDER: Three strips each cut 1½" × 10½"

 (4 × 26.5cm)

 BACKING: 16" × 25" (40.5 × 63cm)

 BATTING: 16" × 25" (40.5 × 63cm)

◆ **SUNRISE OVER MOUNTAIN LAKE (page 93)**

 Enlarge 200 percent, to 4" × 10" (10 × 25.5cm)

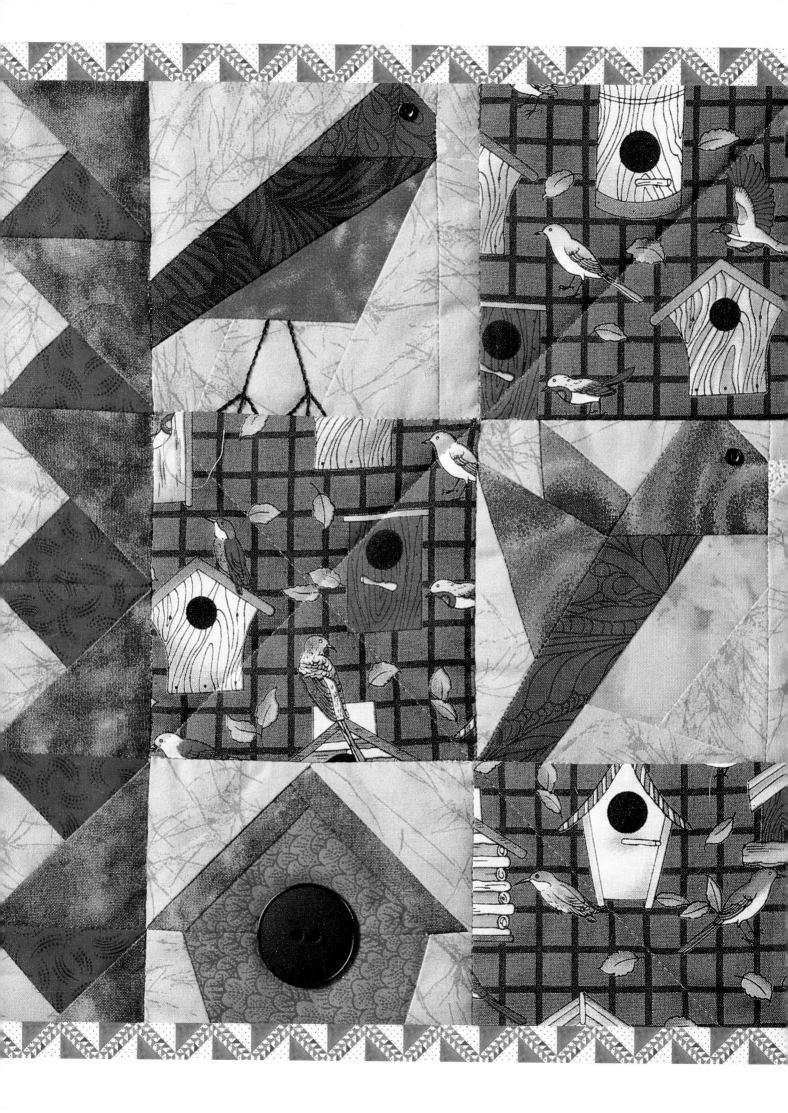

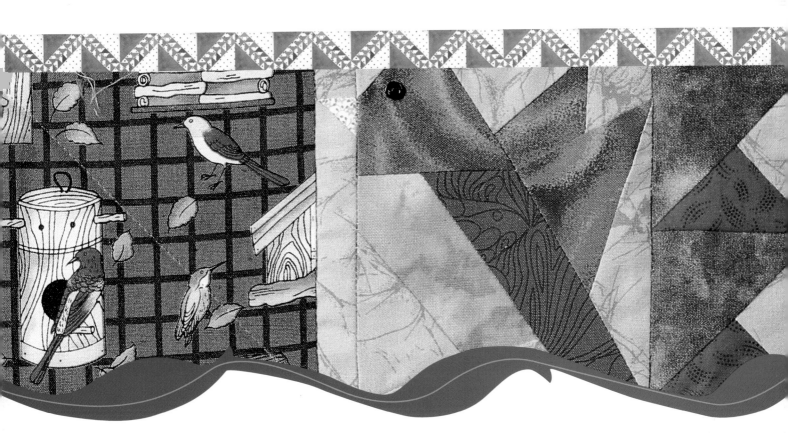

♦ CHAPTER FOUR ♦

FINISHING

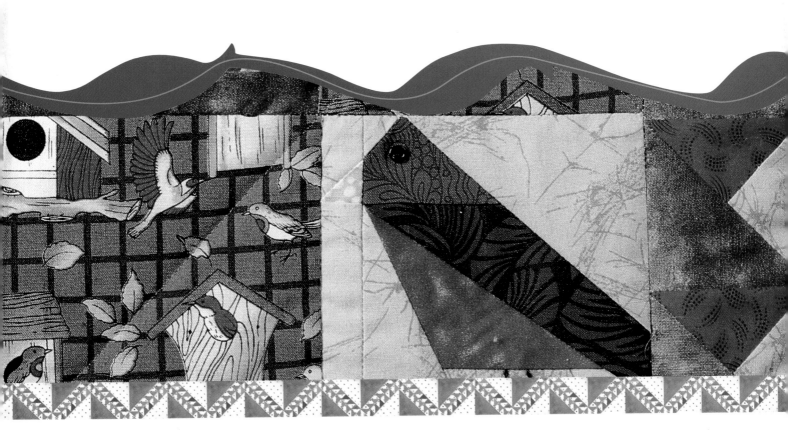

This chapter includes instructions for completing your quilt top; making the quilt "sandwich," binding your quilt, and adding a sleeve for hanging. Refer to the general quilting titles listed in the bibliography for thorough discussions of these topics, as well as for excellent books on machine quilting.

Keep adding blocks until you have completed the top horizontal row. Do the same for each remaining row. Press seam allowances open. Stitch the rows together, carefully matching seams. Press seam allowances open.

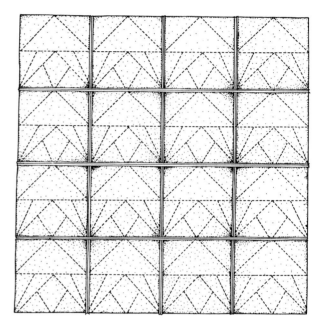

JOINING THE BLOCKS

Lay out the blocks according to the layout diagram for the quilt you are making. Beginning at the top left corner, match the adjoining sides of the first two blocks, right sides together. Pin through the seams to be matched. Baste ¼" (6mm) from the raw edge, as marked on the foundation. Check to make sure seams match and points meet, where necessary. Stitch.

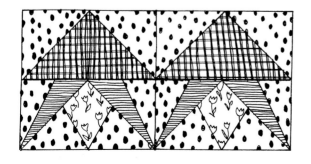

You can measure the finished block to be sure it is an accurate square, not distorted, though this is usually not necessary. On the rare occasion the block is distorted, "block" it by wetting it and pinning it to an exact square of the correct size. Allow to dry. Press.

For easier paper removal, after stitching a seam, score the paper at the seam while trimming. When you're ready to remove the paper, dampen it slightly with a sponge or spray it once with a fine spray. Don't get it too wet. If you do, just press it a bit with a warm iron.

ANNIE TOOTH
MOORPARK, CA

If you've removed the paper foundation before quilt assembly, use spray sizing on your completed blocks before assembling them. This makes them easier to handle and produces smoother looking seams.

ELLEN ROBINSON
GERMANTOWN, MD

For fabric foundations, you can use cotton yardage you no longer want for piecing. Be sure there is no show-through from the print.

REMOVING THE PAPER

If you used paper as the foundation for your quilt, gently tear the paper from the backs of the blocks now, as if you were tearing stamps apart. Press the blocks gently, lifting the iron up and down rather than dragging it, so as not to distort the blocks.

For paper foundations: after sewing two blocks together, pull the paper from the seam allowance. This will enable you to press the seam allowances flat and makes for easier paper removal when the quilt top is complete.

BASTING AND QUILTING

Now your quilt top is ready to be made into a quilt.

1. Cut the backing and batting about 4" (10cm) larger all around than the quilt top.

2. Lay the backing wrong side up on a large, flat surface.

3. Lay the batting on top.

4. Lay the quilt, right side up, on top of the backing and batting.

5. Working from the center out, baste or safety pin the three layers of the quilt "sandwich" together.

Use masking tape for a precise, easy-to-follow straight-line quilting pattern. Be sure to remove the tape immediately after quilting so it won't leave a sticky residue.

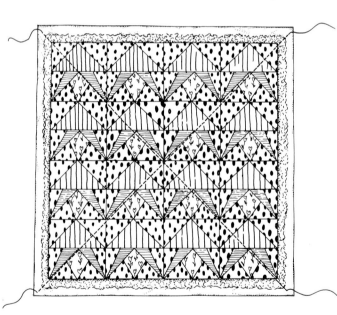

6. Quilt as desired.

7. Remove all basting stitches or safety pins.

BINDING

You may bind your quilt—finish the outer edge with fabric—by either folding the backing to the front and stitching in place, or adding a separate strip of fabric.

NOTE: While a perfectly acceptable finish for a wall quilt, self-bindings may not be the best choice for a bed quilt. For bed quilts, use a separate binding strip. The double fabric in this type of binding will better withstand the wear and tear of everyday use.

SELF-BINDING

1. Trim the batting even with the quilt top. Trim the backing to ¾" (2cm) larger than the outer edge of the quilt top all around.

2. Along one edge, fold the backing ¼" (6mm) to the wrong side. Fold the backing to the front, over the edges of the batting and quilt top. Fold the sides in

first, and slipstitch by hand or topstitch by machine. Repeat at top and bottom.

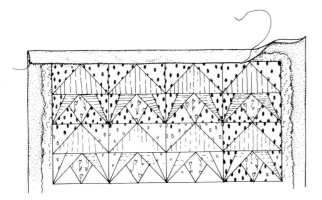

ATTACHED BINDING

1. Trim the batting even with the quilt top.

2. To determine how long a binding to make, add up the measurements of the four sides of your quilt top and add an extra 8" (20.5cm).

3. Cut strips of binding along the straight, crosswise grain (there is some give to the crosswise grain) of your fabric. Use a diagonal seam to piece the strips together.

NOTE: The width of your binding strips is determined by the size of your quilt. For a wall hanging–size quilt the finished binding that shows on the front surface should be about ¼" (6mm). The larger size of a bed quilt requires a finished binding of at least ½" (1.5cm) for proper proportion. As an easy rule of thumb, cut your binding strips 1¾" (4.5cm) wide for wall hangings and 2¾" (7cm) wide for bed quilts.

4. Wrong sides together, fold the seamed strips in half lengthwise. Press.

5. Matching raw edges, place the binding strip along one side of the quilt top on the right side. Machine-stitch the binding to the quilt sandwich, using a ¼" (6mm) or ½" (1.5cm) seam allowance, depending on the desired finished binding width. Leave the first 3" (7.5cm) or so of the binding free so you can join the two ends of the binding later.

For a quilt show–quality finish, join the ends of the binding one-third of the distance from the lower right-hand edge of the quilt. This is the least noticeable join location and is the choice of award-winning quilters.

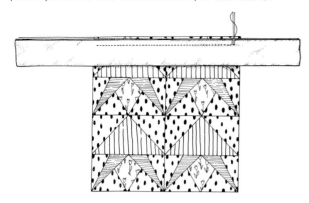

6. Stop stitching ¼" (6mm) from the corner of the quilt top. Leave the needle down, in the fabric.

Pivot, and stitch diagonally to the corner of the quilt and off.

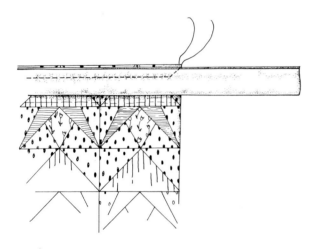

Hold the binding so the loose edge is straight up from the next side.

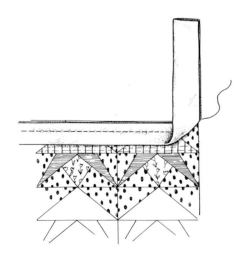

Fold the loose binding edge down, matching the raw edge to that of the next side of the quilt, and continue to sew the next side.

Repeat for the remaining edges.

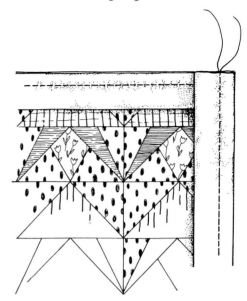

7. When you approach about 4" (10cm) of the beginning of the binding stop stitching. Match the ends of the binding as shown, opening them up to stitch them together along the diagonal. Refold and finish stitching the seam.

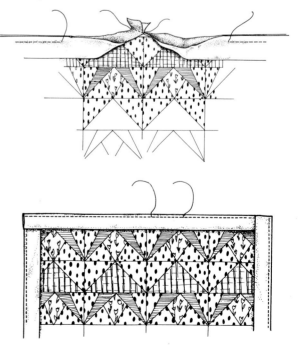

8. Fold the binding to the back of the quilt over the raw edges of the quilt sandwich, covering the machine stitching on the back of the quilt. Slip-stitch the binding in place.

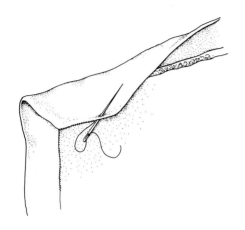

> To build a fabric collection quickly, look for fat quarters at your local quilt store. Fat quarters are one-half of ½ yard (45.5cm) of fabric and measure 18" × 22" (45.5 × 56cm). Fat eighths are also often available. Also, mail-order suppliers (see Sources) carry scrap bags of remnants and precut square assortments.

ADDING A SLEEVE FOR HANGING

To hang a small quilt on a wall, sew a simple sleeve to the back. A rod or ⅜" to ¾" (1 to 2cm) dowel slipped into the sleeve provides the support to hang your quilt nicely. Cut the dowel 1" (2.5cm) longer than the sleeve.

1. Cut a strip of fabric 1" to 2" (2.5 to 5cm) shorter than the width of your quilt and 3½" (9cm) wide. Press each short edge ¼" (6mm) to the wrong side twice. Topstitch.

2. Wrong sides facing, fold the sleeve strip in half lengthwise. Center the strip along the top raw edge of the back of the quilt top before attaching the binding. Baste.

3. Stitch the binding to the quilt as instructed above, including the sleeve in the seam. Slip-stitch the lower, folded edge of the sleeve to the back of the quilt.

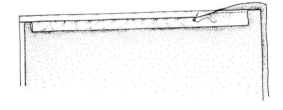

> Identify your quilt with a label. Include your name, the name of the design, date completed, and any other pertinent information.

YOU ARE INVITED...

One of the greatest pleasures in what I do is meeting people who share the quilting passion. Seeing the incredible quilts these talented souls create and sharing the joy of quilting is inspiring and invigorating.

In this spirit, please share your creations with me through the mail or via cyberspace. Whether you use the designs in this book or any other, use these ideas as a springboard for your creativity, or embark on your own creative endeavors, I'd love to see what you're making. I look forward to meeting you.

JODIE DAVIS

Jodie Davis Publishing, Inc.
15 West 26th Street
New York, NY 10010

or via: CompuServe: 73522,2430

Linda is also always interested in hearing from readers. Contact her at the address above or via one of her online addresses.

Internet: quilter@lhsdesigns.jagunet.com

SOURCES

CLOTILDE

2 Sew Smart Way
Stevens Point, WI 54481
(800) 772-2891
Catalog: Free

Sewing and quilting supplies.

CONNECTING THREADS

P.O. Box 8940
Vancouver, WA 98668-8940
(800) 574-6454
Catalog: Free

A large selection of quilt and related books at discounted prices.

KEEPSAKE QUILTING

Route 25B
P.O. Box 1618
Centre Harbor, NH 03226-1618
(603) 253-8731
Catalog: Free or $1 for first-class mail

Pigma pens, books, fabric, huge selection of quilting supplies.

QUILTS & OTHER COMFORTS

1 Quilters Lane
P.O. Box 4100
Golden, CO 80401-0100
(800) 881-6624
Catalog: Free

Books, large selection of quilting supplies.

BIBLIOGRAPHY

Fanning, Robbie, and Tony Fanning. *The Complete Book of Machine Quilting*. 2nd edition. Radnor, Penn.: Chilton Book Company, 1994.

Fones, Marianne, and Liz Porter. *Quilter's Complete Guide*. Birmingham, Ala.: Oxmoor House, 1993.

Hargrave, Harriet. *Heirloom Machine Quilting*. Lafayette, Calif.: C&T Publishing, 1990.

Singer Sewing Reference Library. *Quilting by Machine*. Minnetonka, Minn.: Cy DeCosse Inc., 1990.

Thomas, Donna Lynn. *A Perfect Match: A Guide to Precise Machine Piecing*. Bothell, Wash.: That Patchwork Place, 1993.

INDEX

Apple Trees, 43, *43*, 58, *58*, 116, *116*
Autumn Leaves, 41, *41*, 48, *48*, 111, *111*

Bellflower, 41, *41*, 47, *47*, 115, *115*
Binding, 122–125
Bird, 68, *68*, 73, *73*, 108, *108*
Bird Feeder, 79, *79*, 83, *83*
Birdhouse, 80, *80*, 89, *89*, 108, *108*
Bird of Paradise Flower, 41, *41*, 49, *49*
Block(s)
 asymmetrical, *12*
 designs, 12–13
 joining, 120–122
 piecing method, 17–18
 sizes, 15
 subunit, 19
 symmetrical, 12
Borders
 Brick, 24, 26
 Fence Top, 24, 25, 108, *108*, 113, *113*
 Lattice Fence, 24, 27, 109, *109*
 Twisted Ribbon, 24, 26, 107, *107*
Brick Border, 24, 26
Bright Stars, 30, *30*, 39, *39*
Bunny, 68, *68*, 72, *72*
Butterfly, 68, *68*, 113, *113*, 114, *114*

Cactus Flower, 41, *41*, 111, *111*, 114, *114*, 115, *115*
Carrot, 59, *59*, 62–63, *62–63*, 109, *109*
Charming Garden, 30, *30*, 37, *37*, 106, *106*
Cherries, 60, *60*, 66, *66*, 109, *109*
Clematis Bud, 40, *40*, 46, *46*, 115, *115*
Color, 23
Corner Bud, 40, *40*, 45, *45*, 106, *106*
Corner Rose, 42, *42*, 110, *110*
Corner Sunshine, 92, *92*, 101, *101*, 110, *110*

Fabrics, 15–16
 all-cotton, 15
 grain, 19
 muslin, 13, 16
 nontraditional, 15–16
 preparing, 16
 prewashing, 13
Far Away Vistas, 91, *91*, 97, *97*
Fence Top Border, 24, *25*, 108, *108*, 113, *113*
Finishing, 120–125
Fish, 69, *69*, 76–77, *76–77*, 107, *107*
Floral Whirl, 28, *28*, 32, *32*
Flower Garden, 114, *114*

Flower Stars, 28, *28*, 31, *31*
Flying Bird, 69, *69*, 74, *74*, 108, *108*
Foundations
 options, 13–14
 permanent, 13
 temporary, 14
 transferring designs, 15
Fruit Bowl, 79, *79*, 84, *84*

Garden Birds, 104, 108, *108*
Garden Light, 79, *79*, 85, *85*, 112, *112*
Garden Party, 29, *29*, 34, *34*, 112, *112*
Garden Path, 28, *28*, 33, *33*, 112, *112*
Garden Plans, 104, 109, *109*
Garden Ramble, 30, *30*, 38, *38*, 111, *111*
Garden Toad, 69, *69*, 75, *75*
Good Morning Sunshine, 105, 110, *110*
Green Woods, 90, *90*, 94, *94*, 116, *116*

Hanging sleeves, 125
Japanese Lantern, 78, *78*, 81, *81*, 112, *112*

Lake in the Mountains, 91, 97, 98, 99

Leather Fence Border, 36, 97, 108, 109

Leaf Bird, 43, 43, 50, 53, 111, 111

Leafy Ramble, 110, 111

May Basket, 78, 79, 85, 86

Mountain Lake, 91, 97, 98, 99

Mountains, 92, 92, 100, 100

Mountain Seasons, 112, 113

Mountain Sunrise, 92, 94, 98, 99

Party Lights, 108, 112, 113

Patterns

abstract and geometric

Bright Stars, 30, 34, 36, 39

Charming Circles, 30, 31, 37

Color Daze, 24, 26, 32, 32

Flower Stars, 26—28, 33, 37

Garden Party, 29, 29, 34, 34

Garden Path, 28, 24, 35, 36

Garden Ramble, 30, 30, 38, 39

Inside Tint, 32, 39

Whirling Stars, 28, 30, 36, 38

animals

Bird, 64, 65, 72, 73

Bunny, 65, 65, 72, 72

Butterfly, 66, 66, 78—81, 79, 81

Fish, 60, 62, 70—71, 70—71

Hang Bird, 68, 69, 71, 72

Swan Bird, 66, 68, 70, 69

flowers and leaves

Apple Tree, 50, 51, 58, 59

Autumn Leaves, 50, 51, 59, 59

Bamboo, 51, 51, 57, 57

Bright Petunia, 51, 57, 57

Cabbage Bud, 40, 40, 56, 56

Candy Heart, 40, 40, 54, 55

Leaf Bird, 43, 43, 52, 53

Potted Plant, 42, 42, 56, 56

Shamrock, 43, 43, 55, 55

Spike Flower, 43, 43, 54, 54

Spring Bud, 43, 43, 54, 54

Tall Flower, 40, 40, 44, 45

Water Lily, 42, 42, 53, 53

fruit and vegetables

Carrot, 60, 62, 62—63, 64—65

Cherries, 60, 60, 66, 66

Fruit Bowl, 72, 79

Hot Pod, 59, 58, 61, 61

Pear, 60, 60, 65, 65

Seed Packet, 60, 60, 67, 67

Watermelon, 59, 59, 64, 64

landscapes

Corner Sunshine, 92, 92, 101, 101

Far Away Vistas, 91, 91, 92, 92

Green Woods, 90, 94, 94, 94

Lake in the Mountains, 91, 91, 98, 98

Mountain Lake, 91, 97, 98, 98

Mountains, 92, 92, 100, 100

Mountain Sunrise, 91, 92, 94, 98

Tree Road Home, 91, 91, 96, 96

Tilled Fields and Valleys, 90, 90, 95, 95

Sunrise over Mountain Lake, 90, 92, 98, 98

shapes

Bird Basket, 78, 79, 85, 85

Butterfly, 66, 66, 80, 80

Cabbage, 72, 73, 86, 86

Candy Heart, 101, 78, 73, 85, 85

Fish, 70, 70—71, 80, 80

Fruit Basket, 79, 85, 85

May Basket, 78, 79, 85, 86

Seed Packet, 60, 60, 67, 67

Swan, 66, 68, 70, 69

Watermelon, 59, 59, 64, 64

Water Lily, 42, 42, 53, 53

Pear, 60, 60, 65, 65, 100, 100

Potted Plant, 106, 56, 56, 56, 112

Potted Plant, 42, 42, 56, 56

Tree Road Home, 91, 91, 96, 96

Tilled Fields and Valleys, 90, 90, 95, 95

Seed Packet, 60, 60, 67, 67

Shamrock, 43, 43, 55, 55

Spade, 60, 60, 65, 65

Spike Flower, 43, 43, 54, 54, 115

Spring Bud, 43, 43, 54, 54

Summer Afternoon, 112, 113

Sunrise over Mountain Lake, 90, 90, 92, 98

Tall Flower, 40, 40, 44, 45, 115

Thorn Hat, 20, 28, 112, 113

Summer Seasons, 112, 113

Summer Kitchen Border, 28, 28

Water Basket, 106, 107

Watermelon, 59, 59, 64, 64

Watermelon, 59, 59, 64, 64

Watermelon, 59, 59, 64, 64